REVISED EDITION

The Twelve Steps for Everyone...

who really wants them.

by Grateful Members

CompCare Publishers
2415 Annapolis Lane
Minneapolis, Minnesota 55441

ISBN 0-89638-136-6
Library of Congress Catalog Card No. 77-74840
Third Edition, 1987

Inquiries, orders, and catalog requests
should be addressed to
CompCare Publishers
2415 Annapolis Lane
Minneapolis, Minnesota 55441
Call toll free 800/328-3330
(Minnesota residents 612/559-4800)

21

92 91 90 89

PREFACE

This book, like the Program it describes, is *not* for everyone. It is only for those who need it, want it, are ready for it, and make the effort (great or small) to read it and then continue with it—one day at a time.

To those of you already living a Twelve Step Program—regardless of which one—much of this book will be quite familiar. To those just starting out in one of the Twelve Step fellowships, it may be just what you're looking for, and our hope is only that it may provide a very general guide to the Steps and what they mean to at least a few human beings.

If you are one of the millions who have never heard of the Twelve Steps or any Twelve Step Program, your reaction may vary between "Where has this been all my life?" to "Who needs this?" or "It would be really good for my husband, wife, father, mother; wonder how I can get them to read it?" We have no way of knowing what your reaction will be, though, of course, we hope it will be favorable.

A book such as this cannot be written by one person alone. All that is in it has been graciously given by hundreds of people in Twelve Step programs. It is their thoughts, their feelings, their spiritual awakenings which make up this book, as well as mine and those of my immediate group members. For their precious gift we thank them and are eternally grateful. The Twelve Steps themselves of course are a gift, as explained later in the text—a gift which can never be repaid, and we know need not be because it has already been repaid close to a millionfold. To all of you in all Twelve Step Programs everywhere, we thank you with all our hearts. You are here with us now; you are in this book; you are all a part of us and of our lives.

A Word about Pronouns

In recognition of the equal status of women and men, the first and second editions of this book contained some new pronouns. Rather than use the traditional masculine pronouns "he," "his," and "him" when referring to a person, individual, parent, or child, we coined the new pronouns "hesh" (pronounced "heesh" as in leash) for "he or she," and "hier" (pronounced "hiur" as in skier) for "his or her" and for "him or her." These new pronouns were also used when referring to God.

However, a number of readers were distracted by these new pronouns—to the point of finding it hard to read a book which otherwise might have helped them. Since the primary purpose of this book is to help as many people as possible learn about the Twelve Steps, if even one person who might read this book were deterred from doing so because of difficulty with new pronouns, it would be one too many.

So, in this new edition, we have chosen a more conventional solution to the problem of sexist language than the radical one of introducing new pronouns. At times, we use "he," at times "she," at other times "he or she" or "she or he." We also sometimes refer to the Higher Power as He/She and Him/Her. Through the use of the Twelve Steps, we have learned that, though we came to a Twelve Step Program with a male concept of God, the Higher Power we found here can be a He, a She, both, or neither. Of course, in all Twelve Step fellowships, each member is free to choose the concept of a Higher Power that works best for her or him. In the tradition of these fellowships, we share with you the one we have found to work best for us.

INTRODUCTION

This book is based on the premise that every one of us—whether we recognize it or not—is made up of four major parts: physical (our body), intellectual (our brain), emotional (our feelings), and spiritual (our center, core, our ethereal or cosmic energy, our soul, our spirit). In the Western world over the past thousand years or more, we have directed a great deal of our attention toward the physical and intellectual, and comparatively little toward our emotional and spiritual parts. During the last three hundred years, we have become so enamored of science and reason (products of our brains) that we have wandered quite far from essential spiritual matters such as faith, inspiration, and intuition. In our search for truth, we have had an overwhelming tendency to accept only scientific truth—truth which can be defined, measured, and proven—and to discard as untrue or unworthy of our attention the greater truths of the spirit, of beauty, of peace, and of love.

In our quest for physical comfort, we have pursued and even worshiped material well-being, often at the expense of emotional and spiritual health, having almost completely lost sight of the fact that spiritual health *is* our wealth. And as we become spiritually healthier we need less material wealth but, strangely, always seem to have what we need. Many of us have wondered, lackadaisically or desperately, why, having all the material comforts we could ever have hoped for—or even more—"Why are our lives so empty? Why aren't all these things more satisfying? What is it that's missing? Why am I so blah or even miserable so often or all the time?" Others have wondered just as desperately, "Why have we been so poor materially? Why have we not been as

fortunate as those wealthier than we? Why haven't we had the breaks that others have had?" The answers to such questions are usually difficult to find—especially if we expect the usual "Here's what you need to do" type of answer: "One, two, three and you'll be healthy, happy, joyous, and fulfilled."

Most of us who have been looking for answers for a while through intellectual or physical activity, involvement, psychiatry, encounter groups, and even religion realize that no one can give us the answers—we must find them for ourselves within ourselves—and to find them we must not care too much whether we find them or not. We must care only enough to keep searching. Others can point the way, perhaps, but each of us must travel the road individually. This does not mean that we need travel alone, but neither can we ride on someone else's coattails.

The main reason the answers we seek to fill our emptiness are so difficult for most of us to find is that we do not know where to look. Since we live in a materially and outwardly oriented society, most of us naturally look outside ourselves—more money, more prestige, a better job, a different location, a bigger house, a new car, a new dress, more activities, going to work, going to school, a college degree, a higher degree, a vacation, relaxation, meeting new people, getting married, getting divorced, having children, having an affair, ending the affair, and so on and on.

We not only look outside ourselves for answers to our inner void, our emptiness, but we also look there for the cause of our problems. "She made me angry" rather than "I became angry." "He makes me act like a policeman" rather than "I am afraid of what he might do if I don't control him, so I choose to act like a policeman because when I'm in control, I'm less fearful," or "If it weren't for those awful people at work putting all this pressure on me, I'd be a happy man" rather than "I'm anxious about my performance at work, so I put a lot of pressure on myself to do an extra good (perfect) job and finish everything ahead of schedule," or "If my hus-

8

band would just stop yelling at me (or beating me) all the time, we could have a decent marriage," or still another, "If my parents had treated me better, and had really loved me, I wouldn't be such a neurotic."

In thousands of ways such as these, we attempt to shift the responsibility for our condition and for doing something about it from our own shoulders to those of others—usually those close to us: wives, husbands, parents, children, work superiors, subordinates, or friends. They are the cause of our problems; therefore it is up to them to do something about it. There is nothing we can do to change the situation. This is a place many of us seem to get stuck in until we begin to realize in one way or another that it is our very attitude of holding others responsible—for our well-being or our problems—that keeps us stuck there. Of course, we can't change another person or situation—try as we might—because we are powerless over them. But we can change ourselves—our attitudes and often our own situations.

This is no easy task, and most of us cannot do it alone. We need the help of others who are seeking, just like us, to improve themselves and their lot. But they cannot do it for us. We must do the work with their help.

We often think we need the help of professionals—psychiatrists, psychologists, counselors, or members of the clergy—and indeed some of us do, but many of us do not need to spend long hours and many dollars in a professional's office. We have found a way to help each other to grow emotionally and spiritually and to help ourselves in the process—a way which does not require professional assistance because we already have within ourselves all that is required to fill our emptiness, to solve our problems, to find significance. All we need to make use of our own internal powers is a gentle guide and the proper atmosphere. The way we have found makes use of the basic principles of psychology and psychiatry as well as all the fundamental principles of major world religions from Hinduism

9

and Buddhism to Judaism, Islam, and Christianity. These basic principles are so simple and so encompassing that we do not need professionals to interpret them for us. They are all simply summarized for us in twelve simple steps.

Our way is entirely universal; it excludes no one. It welcomes all without exception. It unifies us with each other and harmonizes us within ourselves. It is a way which each of us is free to internalize in his or her own way and at his or her own pace. In fact, as we have said, it is already within us. All we really need is the willingness and patience to look within, to find it, to bring it into our consciousness, and to use it in our daily lives. That's the difficult part—applying it! But that is only difficult if we try to do it all at once. If we allow ourselves all the time we *actually* have, it becomes easier and easier.

We have said that our way—we actually call it a program, the Twelve Step Program or the Twelve Step path—is based on the major religious tenets of the world—and so it is. Anyone who has studied religions and looks at our Twelve Steps can immediately see connections. Yet the *Twelve Step Program is not religious at all.* Though many people of the clergy and others using this Program maintain harmonious relationships with churches and clergies of all denominations, the Program itself has no religious affiliation and is in no way religious in the sense of doctrine, dogma, codes, or beliefs. In fact, it works just as well for the atheist as for the devout.

It is without doubt, however, a program which helps us to discover the spiritual part of ourselves, to recognize its importance in our lives and to live our lives according to the guidance of this spiritual Self within us, whatever we may wish to call it. We realize that the void, the apathy, the despair we have felt were caused by ignoring, rejecting, and even deprecating our spiritual part. On a physical plane, this would be tantamount to trying to live our lives after cutting out our hearts. Small wonder that we seem to be having such difficulties.

Spiritual and emotional growth is not a journey of a thousand days or a thousand years. It is a journey of now and forever—but only one now at a time. This book can be only a very small step in one phase of the journey. We hope your journey will have many such small steps—one after another—and we rejoice in the thought that we will be traveling with you—though we each travel at our own pace and in our own way. We wish you every good cheer for the most exciting and rewarding trip of your life.

The Twelve Step Path

There is a nonreligious path of spiritual growth, a way of life available to us if we want it, which can help us to integrate ourselves and all our activities into a meaningful, wholesome, joyous life, with a minimum of pain and struggle. This path, often called the Program by those who use it, can relieve our suffering, fill our emptiness, help us find the missing something, help us discover ourselves and the God within us, and release great quantities of the energy, love, and joy dammed up inside ourselves.

This Program can do and has done all this for large numbers of people either in conjunction with other emotional development aids or independent of them. It is a very loosely structured Program we follow at our own pace and interpret in our own way with the help of other people who, like us, are following the same Program. It is a Program of self-development and mutual assistance. All we really need do is become willing to try the Program and open our minds. In fact, if we are willing to try, and do try, our minds will gradually open all by themselves with little conscious

effort on our part. Most of the work will go on in our unconscious, and suddenly we will notice improvements in ourselves, in our awareness, in our sensitivity to our own needs and those of others, in our ability to love, to be freer, to make better choices. In short, we will be consciously surprised by our own spiritual and emotional growth.

Furthermore, this Program is extremely inexpensive (compared to psychiatry or counseling) as it is supported entirely by members' voluntary contributions. It is entirely free for those who cannot contribute. There are no dues or fees, no initiation fees, no membership rosters. In fact, it can be a completely anonymous program; no one need know that you are in it except those people who attend the same meetings you do. Further, you do not join any organization in the usual sense; you do not sign up, take any oaths, or make any pledges to anyone. Though people engaged in this Program hold meetings regularly, there is no requirement to attend any specific number of meetings at any specific time. Meetings are held almost every night of the week, and there are daytime meetings as well.

If there is no meeting in your area at a convenient time, it is not too difficult to start one, though some perseverance may be needed. A meeting may have from two to two hundred attendees depending on the type. There may be discussion, question-and-answer, participation, study, and speaker meetings. Generally the discussion and study meetings are smaller—ten to twenty-five attendees—while the speaker meetings tend to be larger. The meetings are led by a group member on a rotating basis, with a different leader for each meeting. There is no pressure of any kind on anyone to attend meetings, or to practice the Program in a specific way, nor is there any creed or dogma. Members work out their own way, and progress as fast as they can or as slowly as they wish. The pace is individually determined by each person.

This Program is open to all persons regardless of race, color, social class, age, sex, or religious denomination. It is

14

not a religious program, but it is a spiritual one. In fact, religion is never discussed in meetings, but there is a great deal said about a Higher Power as members attempt to arrive at their own concepts of one.

This preliminary description may sound somewhat strange to those not familiar with this Program, and it may sound stranger still that such a loosely knit Program can help anyone develop. But it *can* and *has* helped thousands of people—probably by this time close to one million—on a worldwide basis. Experience shows that it works for *all* those who want it, regardless of the nature of their emotional or spiritual problems. It is gradually becoming a Program of spiritual and emotional development for all who are willing to try it and to develop their capacity for self-honesty.

The entire Program consists of twelve suggested steps, twelve traditions, a few cogent slogans, nonsectarian prayers, books and pamphlets, many meetings of many groups who get together periodically for self and mutual help, lots of telephone contact, and loads of genuine compassion, understanding, care, and love sprinkled liberally throughout.

The meetings which program members attend weekly, or several times per week as they choose, are unique. They are not like group therapy sessions where members may act out their hostilities toward one another. They are not like social or administrative meetings where an endless round of minute items are discussed with only a small number of attendees who are really interested or involved. Rather, there is a minimum of strife, hostility, or the typical organizational undercurrent of jousting for power. There is a great deal of support, concern, and caring as members tell only their own stories and identify with each other's experiences. Above all, there is a great deal of honesty about ourselves—as much as we have been able to muster at a particular point. Rather than hide ourselves, as most of us feel we must in numerous other situations, we are encouraged to reveal

15

ourselves as we are, by the fact that others are doing the same as honestly as they possibly can. If we are not yet ready to reveal anything at any point, we need not do so. There is no pressure but our own. We soon learn that those who might try to pressure us to be open before we are ready, though their intentions are good, are really pressuring themselves and possibly deceiving themselves about their own honesty—as we all tend to do at times.

As in encounter groups, we find that when we honestly share our experiences, we are accepted by the group much more than rejected or ridiculed, as we might have feared. Unlike encounter groups or therapy, however, members are anxious to offer help not by giving advice or by probing into another person's life, but by sharing with each other how, through the principles of this Program, they handle a similar problem to the one being discussed.

What are the principles of this Program? How do we learn them? And how do we put them into practice? The principles are very basic and very simple. They are the principles of emotional and spiritual development which we have heard (but not listened to) all our lives. We have never really stopped to consider these principles seriously, or whether we might really be better off if we tried to live by them. They would make life dull and uninteresting. We would become bored and boring; we would never have any "fun." No, we could not and would not even consider it!

When we begin to realize the importance of our own personal emotional development, however, and begin to see that only by concentrating on our own growth can we ever hope to change anything outside ourselves, we may want to take a fresh look at these age-old principles because their application in our lives will make us sane, sober, serene, and joyous. It will make us free.

These principles, as I see them at this stage of my own development, are not the whole truth—far from it. They are only a small part of it. My search for more truth of life will continue all through my own life, one day at a time, because

16

it is only by searching patiently that I can live evermore fully and serenely. Here is my current understanding of these basic principles of life and of the Program, as I try to live them.

1. If I want to live a peaceful, constructive, free, and joyous life, I must engage in an ongoing search toward my spiritual center, as that center holds all of me together and enables me to grow. When I direct my search toward my spiritual center, I grow emotionally and spiritually.

2. To conduct this spiritual search of myself and for myself, I need to learn to give up trying to control anyone or anything outside myself and many things inside myself as well.

3. A Power greater than myself is guiding my life whether I recognize it or not. The sooner I learn to become aware of, to trust, to use this Power to help me in my search, the easier and less painful my search will be.

4. I am free to use this Power or not, as I will. If I set my will against my Greater Power, I suffer unnecessarily (not because this Power is punishing me or making things difficult for me, but because I make it difficult for myself by not allowing my Greater Power to help me). When I flow with my Greater Power, my life becomes beautiful and serene. The choice is entirely mine.

5. Preferably with the help of my Higher or Greater Power, I gradually need to become aware of, and accept, all the inner workings and contents of my emotional self. I need to become increasingly honest with myself about my past and present attitudes, feelings, emotions, thoughts, behavior patterns, and motives.

6. I need to become increasingly open with at least one other person, but preferably more, about all my emotions and emotional patterns as I discover them.

7. I must increasingly accept myself exactly as I am— without hiding, disguising, distorting, or rejecting any part of myself—and without judging, condemning, or

denigrating any part of myself.

8. My internal rhythm is determined by my emotional and spiritual components, not by my conscious mind. I need to realize that I cannot change as fast as my brain thinks I should, but that I can and do change at a rate determined by my own internal rhythm (no one else's) —so long as I am willing to continue searching.

9. If anyone has wronged me at any time in the past, I must gradually come to forgive that person freely and completely. The sooner I can do this, the sooner I will be relieved of the grudges and resentments which continually gnaw away at my insides and block my spiritual growth. I do this by releasing these people and asking my Higher Power to bless them, to care for them, and to see that only good comes to them. I can greatly help myself in this by doing a kind act for these people, preferably without their or anyone else's knowledge.

10. If I have wronged anyone in the past (no matter how justified I think it may have been), I must freely admit it and eventually make amends and/or restitution where I can. The sooner I can do this sincerely and honestly, the sooner I will be relieved of the increasing loads of guilt I have been unconsciously carrying around for years.

11. Having admitted my wrongs toward others and having made restitution, and having freely forgiven all others of the wrongs done or imagined toward me, I can and must then come to forgive myself for all past wrongs I have done to others and to myself. I need to learn to be good to all of myself, to be gentle but firm with myself, and, most of all, to be as patient and understanding with myself as I try to be with others, and as I hope they will be with me.

12. I need to continue being honest with myself on a daily, and eventually an instantaneous basis. When I discover that I am wrong, I need to learn to admit it as soon as possible (regardless of who else might be wrong too, because that is not for me to judge).

13. I need to realize that my brain is only a small part of me which can neither predict the future nor plan my life to my best advantage. Only my Higher Power can do that, if I let Him or Her. So I need to come ever closer to the Higher Power which is partially within me. I do this through daily or several-times-daily prayers and meditations, asking only to know my Higher Power's will for me and then quiet my mind so that I can hear the answer.

14. I need to work with others who need and ask for my help because *only* by trying to help them can I help myself. Only by freely giving away what I discover and receive can I keep it and use it in my life.

15. As I continue to work on these principles and to become aware of others patiently, ceaselessly and tirelessly, one day at a time, or one minute at a time, I gradually begin to substitute "want to" for "must" or "need to" in all of them. They become an ingrained part of my consciousness as they are already embedded in my unconscious or superconscious. As this process slowly progresses at my own inner pace, I come to experience increasing inner peace, love and joy, regardless of my external circumstances, which themselves seem to improve continually.

These principles are not new. I neither discovered nor invented them. The same principles in different words are found in the Vedic Scriptures of Hinduism, in the Eightfold Path of Buddhism, in the philosophy of the Tao and in the Old and New Testaments of the Bible. Most of us have known them for a long time, but have despaired or disdained of ever being able to live by them. Others have convinced themselves, through self-delusion, that they *are* living by them, and that everything would be all right if everyone else would just do the same. Still others who have come in contact with these principles have rejected them as too demanding or simply unnecessary. Another probably small group has never been consciously aware of these basic

principles and has yet to discover them.

Whether we are aware of them or not, these principles guide our lives whenever we unconsciously let them or whenever our self-will becomes insufficient to cope with our lives unaided. During the past few years, a number of searching and hurting people have been rediscovering these fundamental principles through the Program.

One of the fellowships using this Program is Emotional Health Anonymous (EHA), whose world service office is in Rosemead, California.* Some others are Overeaters Anonymous, Emotions Anonymous, Gamblers Anonymous, and of course Alcoholics Anonymous who originated the Program. These fellowships are intended and ideally suited to help neurotics like us with our multitude of complexes, compulsions, obsessions, manias, depressions, or any other blocks to spiritual and emotional growth.

Strange but true, people in these fellowships find that the same principles apply to the resolution of this wide variety of emotional problems. The reason for this, I believe, is that what we normally consider "problems" are really symptoms, not causes, and that most of these emotional problems can really—deep down underneath—be attributed to the same fundamental cause: a spiritual vacuum, an utter lack or rejection of faith, especially faith in some power greater than ourselves. In our modern, "sophisticated" society, we have destroyed faith as a viable alternative way of life. It is too naive, too primitive, too uncivilized, or perhaps too intangible. Thus we have created within ourselves the spiritual vacuum which leads to the existential anxiety described by Tillich in *The Courage to Be,* and to existential insanity with which most of us are afflicted.

The basic principles we have enumerated above are used by the various fellowships in the form of twelve simple Steps which are suggested as a path of spiritual and emotional growth. Some of these Steps are not easy to under-

*See your telephone book for listings of Twelve Step groups in your area.

stand and even harder to apply, but they are helping thousands of people to lead more peaceful and happy lives than they ever have before. Group meetings aided by reading program literature are the main vehicles through which members broaden their understanding of these Steps. They do this by relating their personal experiences and difficulties in using the Twelve Steps and the principles they embody in all areas of their daily lives. The idea that through this Twelve Step Program we can restore or awaken our faith, begin the lifelong process of spiritual and emotional development, and thereby regain our sanity is not mere whimsy or imagination. It is based on personally experiencing it, and on witnessing the effects on hundreds of others who have tried and are living this program.

Two words of caution before proceeding with our description of the Twelve Steps. The first concerns God. We have said the spiritual development does not require us to accept any traditional concept of God; yet the word "God" or "Power greater than ourselves" appears in six of the Twelve Steps. Here, we must make the distinction between Power greater than ourselves—or God as each of us individually understands that Power—and most traditional concepts of God. The spiritual program of the Twelve Steps is based on developing our faith, and eventually trust, in a Power greater than ourselves, and this Power is referred to as God in the Steps. However, the word "God" is used for convenience only because many people already believe in the existence of God when they come to the Program. So their Power greater than themselves almost automatically becomes God. Though they use the word "God," most of them find, after a while in the Program, that they change their God-concepts quite drastically to suit their new understanding of themselves. This is what is meant by the phrase "as we understood Him." The word "we" in this phrase really means "I" because members of this program are entirely free to individually define their own concepts of a Power greater than themselves to suit their own needs.

For most of us this concept changes considerably as we develop spiritually, but it need not. It is an entirely individual matter.

The Program has members of all religious faiths who find no incompatibility between Program principles and their religions. Many report that the Program has led them back to their churches which they had stopped attending at some point in their lives. Many Program members do not practice any organized religion but find their spiritual components developing through practice of the Program itself. All are welcome regardless of faith or lack of it.

Neither do agnostics or atheists have anything to fear. They will not be required to change their beliefs. Many of us, when we first came in, were agnostic; others were atheists. After some initial struggle, most of the agnostics had no problem developing a faith in a Higher Power of their own understanding whom they often called God. Many atheists did the same, but not all. The Program seems to work for both those who did and those who did not. When agnostics and atheists first come to the Program, they often use an entirely different kind of Higher Power. Their Higher Power might be a tree, a mountain, or an ocean; it might be electricity, or the group whose meetings they are attending, or the Program as a whole, whose principles and members contain the accumulated wisdom of the ages. The choice is entirely up to each individual to find and use whatever Greater Power works best.

A second word of caution is that merely reading the Twelve Steps or our interpretation of them will not produce much spiritual development, if any. If your reading about them here stirs your interest or stimulates your curiosity to the point where you wish to find out more about this Program, then our description will have accomplished its purpose. On the other hand, if your newfound intellectual knowledge becomes an unconscious defense against proceeding with your spiritual development (as it does on occasion for some of us), then we may have done you a disser-

vice. We can only trust for our sake and yours that the former will occur, and press on with temerity (tempered with only a tiny bit of trepidation). Here are the Twelve Steps of EHA. Following the list is a more detailed discussion of each Step.

The Twelve Steps*

1. We admitted we were powerless over our emotions—that our lives had become unmanageable.
2. Came to believe that a Power greater than ourselves could restore us to sanity.
3. Made a decision to turn our will and our lives over to the care of God, as we understood Him.
4. Made a searching and fearless moral inventory of ourselves.
5. Admitted to God, to ourselves and to another human being the exact nature of our wrongs.
6. Were entirely ready to have God remove all these defects of character.
7. Humbly asked Him to remove our shortcomings.
8. Made a list of all persons we had harmed, and became willing to make amends to them all.
9. Made direct amends to such people wherever possible, except when to do so would injure them or others.
10. Continued to take personal inventory and when we were wrong, promptly admitted it.
11. Sought through prayer and meditation to improve our conscious contact with God, as we understood Him, praying only for knowledge of His will for us and the power to carry that out.
12. Having had a spiritual awakening as the result of these steps, we tried to carry this message to emotionally and mentally ill persons, and to practice these principles in all our affairs.

*The Twelve Steps originated with Alcoholics Anonymous and have been adapted by EHA with AA's permission.

Step One
We admitted we were powerless over our emotions — that our lives had become unmanageable.

Step Two
Came to believe that a Power greater than ourselves could restore us to sanity.

Step Three
Made a decision to turn our will and our lives over to the care of God, as we understood Him.

Step Four
Made a searching and fearless moral inventory of ourselves.

Step Five
Admitted to God, to ourselves and to another human being the exact nature of our wrongs.

Step Six
Were entirely ready to have God remove all these defects of character.

Step Seven
Humbly asked Him to remove our shortcomings.

Step Eight
Made a list of all persons we had harmed, and became willing to make amends to them all.

Step Nine
Made direct amends to such people wherever possible, except when to do so would injure them or others.

Step Ten
Continued to take personal inventory and when we were wrong, promptly admitted it.

Step Eleven
Sought through prayer and meditation to improve our conscious contact with God, as we understood Him, praying only for knowledge of His will for us and the power to carry that out.

Step Twelve
Having had a spiritual awakening as the result of these steps, we tried to carry this message to others, and to practice these principles in all our affairs.*

*Each fellowship using these twelve steps uses different wording here. AA uses "alcoholics," EHA uses "other sufferers" or "emotionally and mentally ill persons." Emotions Anonymous uses simply "carry this message" with no specification as to whom the message is carried. "Others" seems a good compromise between the specificity of EHA and the generality of EA. Perhaps we should say "to others who really want it."

Step One

At first glance, Step One seems to be a drastic statement. What "normal" neurotic like us wants to admit that he is powerless or that her life is unmanageable? We all fight to keep our heads above water, to control, to keep from being controlled by others. We compete, we push, we shout, we gesticulate, we clamor for attention to show others how big we are. We have to be first, smartest, fastest, most handsome or beautiful, wealthiest. We have to have the best job. We brag, we show off, and we are proud. We're proud of our home, our town, our state, our country, our children, our acquaintances. We are anything but powerless! On the contrary, we keep shoring ourselves up with the delusion that we are part of the most powerful country on earth; how can we be powerless?

But the truth is that most of us do not come to such a Program or read this kind of book unless we realize that something is wrong; something is missing; something is out of kilter. We go through all the excuses in the book to avoid looking where the trouble is—inside ourselves. But nevertheless, we keep looking; we keep trying to get rid of this feeling that something or that everything is wrong, but it

won't go away. No matter where we look, what we do, it gets worse. It may be a tightness in the stomach, or constant depressions, migraine headaches, high blood pressure, palpitations of the heart, sudden severe attacks of anxiety, or uncontrollable compulsions. Whatever it may be, when all else fails, we are ready for the First Step. We are ready to admit we are powerless over our emotions—the emotions causing the grief, the aggravations, the irritations, the turmoil, the despair in our lives. We have tried all we know to change or to suppress those emotions but we have found that we cannot control them with will power; we cannot overcome them by strengthening our egos. We can possibly suppress them temporarily only to have them burst forth later at the least expected moment and in a most harmful way to ourselves and others. We have no choice left but to admit we are powerless; we are licked by our emotions; we can do nothing effective about them by ourselves. We accept defeat and undoubtedly feel humiliated.

Though this seems like the end of the road, it is really the end of one phase of our life and the beginning of another; the end of the phase in which we rely on our ego and our self-will, and the beginning of the phase in which we gradually learn to rely on our Higher Power. One of the many paradoxes of this Program and of life itself is that when we finally reach and go through this surrender point, we win; and we know that we win because we experience an immediate sense of relief. Though we may feel deeply humiliated by our surrender, which goes against everything our egos have ever learned, that pain of humiliation is mitigated by the knowledge that the fight is over. We need struggle no longer. We have surrendered and it feels good—scary perhaps, but good—because the load which is lifted from our shoulders is greater than the fear of giving up and the pain of continuing the struggle.

Many of us choose to surrender only when we become absolutely convinced that we have truly reached the end of our resources. We have not a single ounce of "fight" left in

26

us. The only alternatives we have, other than surrender, are to go totally insane or to die. At that point, our choice is often not even a conscious one, but is made for us by our Higher Power.

But we need not all go to such depths of desperation before we admit our powerlessness. Those of us who have a lower threshold of emotional pain, or who are more frightened by it, can often see the handwriting on the wall and surrender more willingly before we have reached the lowest "bottom" of sheer desperation and self-torture. These "high-bottom" neurotics may even surrender gradually— one little area of their lives at a time—building faith and trust as they go. Though the depth of our bottom is unique for each of us, the principle of surrender seems basic to all life, even for those who do not reach it until death, and even when their death is by natural causes or old age. The point is that for those of us who surrender early in life, life becomes satisfying instead of frustrating—a joy instead of a constant struggle—because the deep satisfaction of living in harmony with the cosmic forces is so much greater than the transitory pleasure or excitement obtained from any struggle we could imagine or actually wage against those forces.

The second part of the First Step, "That our lives had become unmanageable," is often as difficult for us to accept and may generate as much resistance as the first. After all, we rationalize: "We still hold a job, or manage a house, or get the kids off to school in the morning or to bed at night. So what if we have depressions every three days that last for two days, or so what if we get drunk and break a few dishes or start fist fights with friends and strangers?" But one of the slogans of the Program is: "It's an honest program." And little by little, through listening to others tell their stories in meetings and identifying with those feelings that strike a chord in us, we begin to understand the meaning of the slogan. It means that if we want to improve, we must stop rationalizing, making excuses for ourselves, and admit

27

to at least those areas where our lives are indeed unmanageable: where all our efforts to fix things, patch them up, hold them or us together go for naught; where all our good intentions and resolutions are never carried out, giving way to the invincible power of our obsession, be it a neurosis, a drug, our work, food, or whatever. Usually, as we slowly drop our masks and become more honest with ourselves, we see that our lives are indeed unmanageable, at least compared to what we would like them to be.

Though the First Step may sound like a statement of despair, it merely points out our human limitations which we have so long tried to hide from our conscious selves, and which have prevented us from solving so many of our problems on our own. This is our first step toward the humility we need to find the spiritual guidance that will open new dimensions in our lives. If we wish to be delivered from our problems we must first admit that we cannot cope with them alone.

Step One
We admitted we were powerless over our emotions — that our lives had become unmanageable.

Step Two
Came to believe that a Power greater than ourselves could restore us to sanity.

Step Three
Made a decision to turn our will and our lives over to the care of God, as we understood Him.

Step Four
Made a searching and fearless moral inventory of ourselves.

Step Five
Admitted to God, to ourselves and to another human being the exact nature of our wrongs.

Step Six
Were entirely ready to have God remove all these defects of character.

Step Seven
Humbly asked Him to remove our shortcomings.

Step Eight
Made a list of all persons we had harmed, and became willing to make amends to them all.

Step Nine
Made direct amends to such people wherever possible, except when to do so would injure them or others.

Step Ten
Continued to take personal inventory and when we were wrong, promptly admitted it.

Step Eleven
Sought through prayer and meditation to improve our conscious contact with God, as we understood Him, praying only for knowledge of His will for us and the power to carry that out.

Step Twelve
Having had a spiritual awakening as the result of these steps, we tried to carry this message to others, and to practice these principles in all our affairs.

Step Two

Newcomers to the Program often find two main trouble spots in this Step. The first is a belief in a Higher Power, as we have already remarked; the second is the implied admission of insanity. When we first encounter these Steps, many of us wittingly or unwittingly have allowed ourselves to move quite far from anything spiritual. Many of us don't even like the sound of the word "spiritual"; others don't understand its meaning. For one reason or another—too many activities, too much attention to daily chores or struggles, too much emphasis on material concerns—we have separated spirituality from our lives or at least from our consciousness. Perhaps we have prayed too many prayers which we felt were not answered; perhaps we have felt unworthy of our Higher Power's attention; or perhaps we have shied away from dependence on anything or anyone because we felt that we should do it all ourselves—we were too afraid or too angry to trust. Whatever the reason, we have been disappointed in God and have given Him up as we often felt He had given us up.

Even those of us who have continued to practice a religion over the years and to attend services regularly have

often been less than satisfied with the results. Somehow, the words of our clergyperson, which were often soothing while in church or temple, were quickly forgotten or acquired a hollow ring in the hustle and bustle of daily activities or the inactive despair of a deep depression. Little did we realize that we might just possibly be placing our will between ourselves and our Higher Power; that we had come to rely on our own will because it was ours alone. No one could take it away from us. Relying solely on our will, we did not have to trust anyone. This suited us just fine because we had become so afraid to trust.

But the thousands who have tried this Program have succeeded, once they had really surrendered in Step One, to find or rediscover a Higher Power of their own understanding. Perhaps they were helped by the fact that no one in the Program told them *what* God they should believe in. Quite the contrary, what they heard were countless suggestions that they find their own God.

For agnostics and atheists, even this is too much. To them, group members suggest that they conceive of any power they can so long as it is greater than themselves. Initially, as we have said, this power can be anything from the group to the Program itself, its principles, or even a light bulb.

Amazingly, thousands have found that all that is required to "come to believe" is to attend meetings, to be willing, and to keep an open mind. If those conditions are met, the rest seems to come about without the use of our will or even our conscious mind. Our unconscious is working at all times—even in our sleep. If we are *willing* to have our conscious blocks to belief removed, our unconscious, which for many of us is where God resides, will do the rest and we will eventually "come to believe." Many of us who want to make a greater conscious effort try to begin to see chance events or coincidences in our lives as miracles or gifts from our Higher Power, whatever the Power may be. We may feel silly doing this at first, but we find that each time we do it,

our faith is reinforced a bit, until we truly come to believe. It is surprising to most of us how little practice we need before we no longer feel the slightest bit silly, and how much easier life becomes once we develop even a tiny bit of faith.

The second hang-up in this Step, "restore us to sanity," implies what many of us do not like to face in ourselves—the fact that we are insane. This Step does not actually say that, but does make a strong implication that we do suffer from some kind of insanity; that we behave insanely in many areas of our lives; that in many ways we lead an insane existence. In short, this step implies that we are, if not emotionally insane, at least existentially insane—and it is often difficult to tell the difference.

We need only begin to look at ourselves honestly to find a multitude of examples of our insanity—not the other person's insanity, but our own, individual insanity. That is what we must face if we wish to change it. It is relatively easy for alcoholics or overeaters or drug users or gamblers to discover their forms of insanity because they have addictions which lead to behavior which is visibly and "acceptably" insane. The alcoholic becomes increasingly blind, stumbling drunk, and literally throws away all that he or she loves and from whom he or she derives comfort. The overeater becomes overly and visibly fat against doctors' orders, often with heart or kidney conditions or diabetes, all aggravated by overweight. The gambler loses valued possessions.

But it is much harder for those of us afflicted with nonvisible insane behavior to admit to insanity. It is easier for us "normal" neurotics to deceive ourselves. Again, one way to cut through our self-deception is to attend as many meetings as we can to listen to others' stories. Sooner or later, we will hear someone else identify something they do as insane, which we realize we also do, and slowly we will come to the realization that *anything we do or think that is destructive to ourselves or to someone else is insane.* Viewed in this light, worry is insane, unrealistic fear is insane, depres-

sions are insane, just as are compulsions and obsessions of all kinds, the attempt to control anything or anyone, and any kind or degree of negative thinking.

Both the admission of insanity and the beginning of a belief in a Higher Power require the essential ingredient of humility. Just as we needed humiliation to surrender in the First Step, so do we require humility in the Second Step to believe that a Higher Power can help us. In fact, humility is a recurring theme of the Program. To a great extent, it was our lack of humility which got us to the insane position we are in; and this in itself should help us to try another way— that of becoming humble. Like every part of this Program, this is more easily said than done. But one important reason why we need to attend numerous meetings, especially as newcomers, is to discover the blocks to humility within ourselves. We do this by listening to others who have had similar blocks, and by hearing how these were removed for and by them. We also do it by witnessing the warmth, serenity, and joy which come to those who accept and live this Program. By associating with such people at meetings, many of their positive attitudes and their humility eventually "rub off" on us, or sink into us. They are contagious also—just as were our previously acquired negative attitudes of gloom and pessimism.

Step Two is often called the Hope Step. Whereas in Step One we feel hopeless, licked, beaten as we surrender, Step Two gives us new hope as we begin to see that there is help available, if we will just "come to believe." There is a Power greater than ourselves which we can learn to use to solve all the problems we have not been able to handle by ourselves. We need no longer struggle alone. We can learn to build our faith in this Power, as others have done before us. We can learn to think of this Power in any way which makes us comfortable: Father, Friend, Partner; infinitely loving, helpful, understanding, powerful, benign; constantly close to us and ready to help us whenever we ask. With a Friend like that, how can we help but begin to feel at least a glimmer of hope?

Step One
We admitted we were powerless over our emotions — that our lives had become unmanageable.

Step Two
Came to believe that a Power greater than ourselves could restore us to sanity.

Step Three
Made a decision to turn our will and our lives over to the care of God, as we understood Him.

Step Four
Made a searching and fearless moral inventory of ourselves.

Step Five
Admitted to God, to ourselves and to another human being the exact nature of our wrongs.

Step Six
Were entirely ready to have God remove all these defects of character.

Step Seven
Humbly asked Him to remove our shortcomings.

Step Eight
Made a list of all persons we had harmed, and became willing to make amends to them all.

Step Nine
Made direct amends to such people wherever possible, except when to do so would injure them or others.

Step Ten
Continued to take personal inventory and when we were wrong, promptly admitted it.

Step Eleven
Sought through prayer and meditation to improve our conscious contact with God, as we understood Him, praying only for knowledge of His will for us and the power to carry that out.

Step Twelve
Having had a spiritual awakening as the result of these steps, we tried to carry this message to others, and to practice these principles in all our affairs.

Step Three

At first glance, this Step seems to require even more of us than did the first two. No sooner do we admit powerlessness and come to believe that a power greater than ourselves can restore us to sanity, than we are asked to turn ourselves completely over to this Power with total abandon. This is too much! At this point it is well to remember that everyone works this Program on his own time and in her own way; that nothing is forced down our throats, but merely suggested. If we feel pressured, we are going too fast. We need to slow down and give ourselves all the time we need to become ready to proceed. If we try to proceed before we are ready (and most of us do, being partly the product of an impatient society), we will have to backtrack later again and again (most of us do that as well). It is also good to remember that we do not need to swallow any Step all at once. With all of these, we may try, experiment a little at a time at our own pace. The important thing is to keep trying and to be willing, and it will come.

Our experience tells us that the more willing (therefore, the less defiant or belligerent or stubborn, or even passively resistant), we are, the faster the Program "will come to us,"

the faster we will "get" its meaning and be able to live it. But it is *not* true that the harder we try, the faster it will come. We must keep trying, but try gently. If we try too hard consciously, we will become too impatient, and block our own progress with frustration, irritation, and perhaps resentment and self-pity as well. Perhaps the words of Emerson express this idea best: "There is a guidance for each of us, and by *lowly listening* (emphasis added), we shall hear the right word. Certainly there is a right for you that needs no choice on your part. Place yourself in the middle of the stream of power and wisdom which flows into your life. Then, without effort, you are impelled to truth and to perfect contentment."

For many of us, the central idea of the Third Step is best expressed by an important slogan of the Program: "Let go and let God." "Letting go," or as it is stated in the ancient Chinese philosophy of Tao, "Letting Be," is an essential part of this Program, but again, as with everything else, it is only suggested. This idea of letting go can greatly help us to take this Third Step, because what we are asked to do, in effect, is to let ourselves go into the hands of our Higher Power. Instead of using our will, let us find out what His/Her will for us is; and instead of trying to control our own lives, let us let God guide them.

Letting our Higher Power guide our lives becomes a little easier when we admit that we haven't really done such a wonderful job of it so far. But that is not enough. We need to look again, at what kind of a God we have chosen to believe in; for if we are to turn our will and lives over to God's care, He must be a God we can trust. For many of us who have taken this Step, God, *as we understand Him,* is just that—infinitely loving, kind, and concerned for our welfare, not meddling in our lives, or judging or condemning us when we err; nor does He tell us what to do *unless we ask* and are willing to listen to the answers. And even then, it is only gentle guidance, not orders or commands. Furthermore, He does not scold or punish us if we do not follow this

guidance; He merely waits for us to ask again, for God, *as we understand Him,* has infinite patience, infinite love, infinite understanding, and infinite compassion. He has given us free will, so He will never force Himself on anyone. He has no chosen people, no favorites; we must choose Him, not the other way around. His help is always available to all who want it, around the clock, everywhere in the world and the universe. God, *as we understand Him,* does not expect us to do anything *for* Him, for He gives infinitely without expecting anything in return. He does not expect us to pray or go to church or temple, or build great edifices in His name or engage in any form of rite, ritual, or worship whatsoever. We need not pray in any special way. God understands all languages in words, thoughts, deeds, but especially the language of the heart.

For those of us who consider Him our Father, we are all His children. He would like nothing more, we believe, than to have us like and love ourselves, love one another, and behave joyfully toward one another, but He realizes we must do this for ourselves. He knows we cannot do this without His help, for He is all-knowing, but He will never give us this help if we don't ask for it. Yet His help is always near if we want it, and are ready to receive it.

For those of us who believe God to be within each and every living being and nonliving thing in the universe, including our own hearts, or guts, or heads, He responds when we seek His guidance through frequent meditation. In the East, many people know this and have approached Him more closely than any other people on earth of whom we are aware. But we in the West have ignored, questioned, or rejected Him. Even this will not "injure His feelings," for He is infinitely forgiving and available to us at any time we want Him, regardless of how we have behaved in the past. He is as available to people who have been thieves, rapists, and murderers as He is to those who have been law-abiding citizens. He will never let us down if we turn our wills and lives over to His care completely. The problem in contact-

ing and communicating with God lies not with God; it lies with us. God does not reject us; we reject Him. Even those of us who feel that He rejected us were not rejected by Him. We feel that we were, only because we asked Him to fulfill our wishes and desires or to carry out our will, rather than turning our will over to Him and seeking to know His will for us as Step Three suggests.

This begins to describe, however partially and inadequately, the God many of us have found in this Program. God, of course, can never be known or described completely by us since God is infinite and we are limited. His love and power are greater than we can possibly imagine, and for some of us the fact that it is so great, and yet never flaunted, is difficult indeed to understand. Though the description above is my own as I have selectively assembled it and set it down, its elements are far from original. If it vaguely resembles the God of Christ, of Hinduism or of the Tao, it is only because time can never modify fundamental truths; only people do. My Higher Power is a composite of the positive aspects of all the scriptures of the East and West and of partial descriptions heard at Program meetings.

Many of us have also found our God willing to grant us anything we truly desired, whether we specifically asked for it or not, on two conditions: (1) that what we desired was really in our best interests, and (2) that we were ready and willing to accept it. In the past, we often desired and asked for things which were not in our best interests, though we did not realize this at the time. Even then, God often granted us these wishes so that we might learn for ourselves that we do not always—and for some of us it's very seldom—know what is in our best interest. This is so because we lack spiritual and emotional development. There is a saying in the Program: "Be careful what you ask for; you might get it!" How true this has been for so many of us. When we received the things we asked for, we often found they were not what we wanted after all.

40

Gradually, though, as we turned more and more of our will and our lives over to our Higher Power, we began to realize that we were very well taken care of. This did not mean that we could abandon ourselves to God expecting Him to do the whole job for us. We learned that there was still some "footwork" to be done by us. We needed to find out God's will for us, and then use our will to initiate and execute the necessary actions to carry out His will. The execution of God's will, the "footwork," was still up to us. He had become our Director, and we the executors. We realized that when we try our best to make our will conform to our Higher Power's, we begin to use it the right way. Instead of attacking our problems with all the will power at our command, as we formerly did, we now try to use the Steps and the Program to help us align our will with our Higher Power's intention for us on a daily and eventually constant basis.

Those of us who are afraid that turning our wills and lives over to a Higher Power means that we will become dependent on the Power, and therefore weak or cowardly, had better take another look at dependence. To be sure, prolonged dependence on any human power would eventually bring us completely under the control of that individual, and thereby enslave us and make us weak. But dependence on a Higher Power which is infinite, can be tapped whenever needed, does not impose itself upon us, and can only make us stronger. But by using that Power, we transcend ourselves. The God we have found does not want us to be poor, forlorn little sheep wandering about aimlessly or moping around feeling like slaves. He seems to want us to be strong, capable, competent and creative, and is willing to give us as much of His inexhaustible power as we need to accomplish His will. Dependence on a greater Power which never runs out is not enslavement; it is freedom through transcendence of our human limitations. The more we come to depend on our Higher Power, the more independent we become. Though this is another paradox, depen-

dence, as we practice it in the Program, is really a means of gaining the true spiritual independence we all seem to seek.

One more point on Step Three. Many of us look over our world, and we say "How can there be a God such as the one you describe—infinitely kind, concerned and loving, with all the killing, starving, violence, and other forms of inhumanity going on? If there really were such a God, would He not put a stop to all this?" Such questions, it seems to us, are framed in the wrong context. The question does not take into account the nature of the Power we have described. It implies that God is controlling, meddling, and directing with a heavy hand everything that goes on in the universe. We do not believe this is so; in fact quite the opposite. The power of God is not controlling; it is sustaining. It is not meddling; it enhances human freedom. It is never used in restraining ways; thus it does not interfere with human beings' free will. The point is that when we are not ready to do God's will, but would rather substitute our own, we are perfectly free to do so. God will not interfere, so we are on our own; we must depend on our own power, which, though great at times (e.g., nuclear bombs), is puny compared to God's. Furthermore, we seldom seem to know what is in our best interest, and thus misuse our power, which results in killing, suffering, and misery.

But when we become ready to do God's will, humbly ask to know what this is, and are willing to carry it out, then we are given all of God's infinite power which we need to carry out the tasks at hand. God does not create the suffering in the world; we do so by ignoring God and by putting ourselves in His place. We—each one of us—can stop the suffering by choosing to do God's will. It is our choice. God will neither force us nor choose for us.

42

Step One
We admitted we were powerless over our emotions — that our lives had become unmanageable.

Step Two
Came to believe that a Power greater than ourselves could restore us to sanity.

Step Three
Made a decision to turn our will and our lives over to the care of God, as we understood Him.

Step Four
Made a searching and fearless moral inventory of ourselves.

Step Five
Admitted to God, to ourselves and to another human being the exact nature of our wrongs.

Step Six
Were entirely ready to have God remove all these defects of character.

Step Seven
Humbly asked Him to remove our shortcomings.

Step Eight
Made a list of all persons we had harmed, and became willing to make amends to them all.

Step Nine
Made direct amends to such people wherever possible, except when to do so would injure them or others.

Step Ten
Continued to take personal inventory and when we were wrong, promptly admitted it.

Step Eleven
Sought through prayer and meditation to improve our conscious contact with God, as we understood Him, praying only for knowledge of His will for us and the power to carry that out.

Step Twelve
Having had a spiritual awakening as the result of these steps, we tried to carry this message to others, and to practice these principles in all our affairs.

Step Four

Though the first three Steps required primarily thoughts—surrender, belief, decision to rely on a Higher Power—with the Fourth Step starts the action part of the Program. We have found in this Program that self-knowledge is an essential ingredient of emotional and spiritual development. In fact, it is what emotional development is all about. Without it, our true selves, including our real emotions, motives, and defects remain hidden in our unconscious, causing all the turmoil, grief, pain, distortions, and frustrations which have led us to this Program, or at least to read this book.

In addition, these unseen, unconscious emotions, motives, and effects, if left unattended, can only fester and become increasingly destructive to our serenity, peace and joy until they lead us to total insanity or to another form of self-destruction. Many of us, who have refused to look within for most of our lives, are well on our way. As with a neglected boil, the infection spreads until it threatens our total being. Like the boil, the unconscious mind must be lanced; the infection must be expurgated. The process for doing this is "a searching and fearless moral inventory." It will

clear the air; it will clear our minds; it will be the beginning of our capability to adopt new attitudes, to "let go of our old ideas absolutely," to expose and admit our "stinking thinking." The inventory itself may provide us with an immense sense of relief as all the accumulated emotional pus (some call it garbage) comes gushing out of us. It may also release considerable amounts of energy which we previously used to dam up all the emotions we could not face.

But how do we go about this process? How do we take a searching and fearless inventory of ourselves?

As with everything else in this Program, there are as many answers to these questions as there are people in the Program. But the Program literature suggests a way which many have found helpful and which, when the time comes, you may wish to follow as well. First, it is of immeasurable help to have thoroughly taken the first three Steps. For without the humility which comes with the First Step and the reliance on and trust in God as we (you) understand Him, which comes with the Second and Third, we cannot be ready for the Fourth. Without faith in a Higher Power, a truly searching inventory would be excruciating and a fearless one would be impossible. We would become fearful and guilt-ridden to the point where we could not continue.

Many of us who have tried this in psychotherapy, even with the help of a demigod (to us) therapist, know the pain, the anguish, and the self-beating that process entails. But with the help of our infinitely forgiving Higher Power and the patient understanding of our Program sponsor, we can proceed fearlessly, or at least with greatly reduced fear.

One suggestion is that we write down our resentments, fears, guilts, and a detailed account of our sexual behavior if that has been a problem. We may then review these to determine why we have these fears, resentments, and guilts, and we will usually find that they result from threats to our ego, loss of self-esteem, or injury to our pride. When we do this, our old enemy "self" crops up again.

We have seen before how we must transcend our selves if

46

we are to have peace and serenity. But before we can do this, we need to face all the unpleasant—or what we consider undesirable—aspects of ourselves. We need to understand where these come from, why we have them, what motivates us, and we must then consciously accept these parts of ourselves which we have previously kept hidden from our view. Only then do we have the humility and the honesty to see ourselves as human children of God rather than the "perfect" God-like beings we tried to be (but knew underneath we could never be). We have already seen that the only way we can approach Godliness is in a true spirit of humility, by fully admitting and accepting our human ungodliness. Or put another way, God's Power is infinitely humble. To make ourselves ready to use it, we must become humble as well.

Another suggestion for taking an inventory is that we review in writing our desires, thoughts, motives, and actions in terms of that old standby set of human failings—the Seven Deadly Sins. These are pride, greed, lust, anger, gluttony, envy, and laziness. Though many of us do not like the word "sin," we might think of them as character defects, and might well add fear to the list. If we do this honestly, we will probably find that fear underlies all other defects. Pride is fear of humility; greed is fear of wanting—not having enough; and lust is often motivated by fear of rejection.

We often use anger to mask fear since the former is a more acceptable emotion than the latter. Gluttony and envy also result from fears of rejection or worthlessness; and laziness from fear of responsibility. So fear—fear of facing ourselves, fear of facing the world, fear of facing life or fear of losing—is usually undercover enemy number one, who is often disguised as resentment or anger. We learn in the Program that the replacement for fear is faith. When we believe and trust in our Higher Power, we no longer fear. As our active faith grows, our fear diminishes.

One suggested method of inventory taking is to do it in

47

two parts: "A simple form, then later in a detailed form. The first, or simple, part may be taken by members after only a short time in the Program. The second part should not be taken until the person understands the Program more thoroughly. If, while taking either the simple form, or the long form, you get overly anxious or upset, put it aside. You are not yet ready to take it. Start it another day. This is a [difficult] Step which must be taken, but don't force it" (*Getting Started on the Fourth Step,* EHA, 1973).

The EHA pamphlet goes on to suggest that we make a list of all the events in our lives that made us happy, starting as early as we can remember. For example, "Seven years old, on rock preaching to other kids," "Junior High School, on staff of school paper," "Graduation from High School," "1945, got out of service," etc., leaving space between them. Then it is suggested we start a similar list of all events which made us feel bad or times when things did not work out well for us. For example, "Eight years old, couldn't go swimming with brothers," "Ten years old, couldn't go hunting with brothers," "Twenty-two years old, couldn't keep a job," etc.

The suggestion goes on to tell us to update and complete these lists anytime we think of an omission when we originally made the lists. Then we are told to put these lists away for a while and to think about them every so often, trying to be as honest with ourselves as we can. After about a week, we are to take out the lists again and perform the second part of the inventory. We write down next to each item in the "good" list *why* it made us feel good, and the same for the "bad" list, but being *really* honest with ourselves for these "bad" items. The writer goes on to tell us: "If you are like I was, you will realize that you had been using excuses and blaming others in the past for your shortcomings. None of this now, let's get to the truth" (Ibid. EHA).

Another suggestion for those of us who are so inclined has been to write out our entire life story from the time we were small children, remembering especially *how we felt.* The

process of writing for some of us produces a self-supporting, cathartic flow, a cleansing process which itself may release a great deal of pressure.

The suggestion of listing both good and bad events reminds us that the process is not only one of dredging up all our faults, but rather of seeing ourselves more realistically as combinations of desirable and less desirable features. In fact, many groups offer an inventory guide sheet which contains two columns, one for assets and one for liabilities. The reason liabilities are usually emphasized more than assets is that it is the liabilities which cause all our problems. They are the more difficult to root out and to be honest about. It is much less difficult for us to admit that we are capable, competent, and responsible in our jobs (if that is indeed the case) than it is to accept that we are self-centered, selfish, and uncaring in our relations with our families. However, in the process of working on our faults, we must resist the tendency to forget our good qualities. We need to include them and learn to appreciate ourselves for them.

A fifth way of taking our inventory—though most difficult at first—is to look at ourselves with increasing honesty without judging what is good or bad, desirable or undesirable. Our goal is eventually to accept all that we find within us. When we place a judgment on it or label it right or wrong, good or bad, we defeat our purpose because we want to see only the good and tend to reject or ignore the bad. When we finally begin to see the bad, we are so overwhelmed by it that we condemn and hate ourselves needlessly with a great deal of consequent pain and suffering. If we merely observe ourselves without judging, our task of self-acceptance becomes much easier. Because we have become so accustomed to making judgments of everything and everyone around us, as well as ourselves, most of us need gradually to unlearn our judging habits by gently but persistently reminding ourselves that we now want to accept rather than judge, and that judging interferes with acceptance. Rather than taking ideas for or against various

parts of ourselves, we now want to adopt the neutral attitude of an impartial observer of ourselves.

Having completed our own inventory by whatever method was most comfortable for us, we are now ready for Step Five.

Step One
We admitted we were powerless over our emotions — that our lives had become unmanageable.

Step Two
Came to believe that a Power greater than ourselves could restore us to sanity.

Step Three
Made a decision to turn our will and our lives over to the care of God, as we understood Him.

Step Four
Made a searching and fearless moral inventory of ourselves.

Step Five
Admitted to God, to ourselves and to another human being the exact nature of our wrongs.

Step Six
Were entirely ready to have God remove all these defects of character.

Step Seven
Humbly asked Him to remove our shortcomings.

Step Eight
Made a list of all persons we had harmed, and became willing to make amends to them all.

Step Nine
Made direct amends to such people wherever possible, except when to do so would injure them or others.

Step Ten
Continued to take personal inventory and when we were wrong, promptly admitted it.

Step Eleven
Sought through prayer and meditation to improve our conscious contact with God, as we understood Him, praying only for knowledge of His will for us and the power to carry that out.

Step Twelve
Having had a spiritual awakening as the result of these steps, we tried to carry this message to others, and to practice these principles in all our affairs.

Step Five

The further we go into this Program, the more humility it requires of us, or rather we require of ourselves. It has taken a great deal of humility to become ready for Step Five. But Step Five is the test of our humility. Are we truly humble, or do we just *think* we are? Are we truly humble in the sense that we see ourselves as one human being in a sea of human beings, all of us children of God? Are we truly humble in the sense that we are beginning to rely increasingly on our Higher Power in more and more of our affairs, substituting His/Her will for ours? How can we be sure? Step Five offers us a way to put our humility to the test. If we are truly humble, if we do accept ourselves as we are with all our shortcomings as revealed in our inventory, we will not have too much trouble taking Step Five, once we find the right person with whom to do it. If we are not truly humble, or if we are humble only in certain areas with reservations or false pride in others (which is the case for most of us), it will show up in our ability to take this Step, and by taking it, our humility will be deepened.

In Step Four, we have set down all the defects of character of which we were aware at that point, as well as our good

points. Now in Step Five, we think deeply about these, and admit them completely to ourselves as well as to God. When we do this with all the humility we can muster, we find God willing to forgive us and accept us in spite of our shortcomings, past errors, and present deficiencies, if we are willing to forgive ourselves. The really difficult thing for most of us is to sit down face-to-face with another individual and admit to him or her "the exact nature of our wrongs." A multitude of misgivings slow us down. Even assuming we can carefully choose a trustworthy, close-mouthed person who will keep our confidences, will he laugh at us? Think us silly or ridiculous? Or worse yet, will she think us weird, despicable or base? Will he become disgusted with us for the horrors we reveal? It is one thing for all-forgiving God to forgive us and accept us for what we are, but can we reveal all our "ugly" secrets to another human being and expect to be accepted and understood?

If we have taken a thorough inventory in Step Four, these fears of ridicule and rejection will all be a part of it, down there on paper in black and white, and we will realize they stem from our need to present a "good" image of ourselves to everyone because we fear that, if we don't, they will have nothing to do with us; we will be isolated and outcast, and therefore worthless. But on closer reflection, isn't it just that need to "doctor" or distort our image which has built the real barriers between us and the rest of the world, which in fact does isolate us in spite of—or perhaps because of—the false front we present? Nothing draws us to others and others to us like honesty and humility. For they represent true humanity, and that is what really attracts us to each other.

Another one of the paradoxes of life is that there is no way to find this out except for us to be as completely honest as we can; in other words, by going through Step Five in spite of our fears. Usually, this brings immediate dividends. The sense of relief we may have experienced in taking our inventory is now magnified tenfold because we have

really gotten all those nasty secrets out of our system and have found acceptance in spite of (or because of) them. If our inventory-taking was a harrowing experience because it dredged up long-forgotten guilts and remorse, then a Fifth Step immediately or soon thereafter can go a long way toward relieving the guilt and anxiety we may be feeling. Invariably after a Fifth Step, we feel more a part of the human race, closer to our fellows, and much less of a freak. Our self-worth increases; a deep sense of well-being comes over us as never before. We begin to get an inkling of what real serenity can be like.

We may need to be careful in choosing the person with whom we take the Fifth Step. We may want to take it with our Program sponsor or with an understanding person not connected with our Program. It may be a clergyperson, psychiatrist, counselor, or close friend. Above all, it must be someone we can trust to be absolutely close-mouthed, someone we know to be understanding and accepting without feeling sorry for us. The choice is entirely ours, and must be a person with whom we can be completely comfortable. We may even choose someone we have never met before and will never see again.

Those of us who have been in psychotherapy prior to coming into the Program already have taken a form of the Fourth and Fifth Steps with our therapist, and for those who were truly honest, this may be sufficient. But others who need to be more thorough may be nagged by the idea that the therapy inventory was not in writing as suggested in the Program. For those, it may become necessary to take a more comprehensive written inventory, particularly if anything was withheld from the therapist and thus never worked through in therapy. Many of us tried therapy in desperation for only a few weeks or months, and not obtaining sufficiently rapid results, gave up, feeling hopeless and rejected. Undoubtedly, this type of curtailed treatment was not sufficient to take the place of a thorough Fourth and Fifth Step. It seems that only an extended therapy period of

several years might possibly do the job, if it was completely honest. If not, we will undoubtedly feel the need to take a more thorough written inventory, and to discuss it openly with the right person for us.

We often ask, "Why do I have to discuss my wrongs with another person? Why isn't it enough for me to admit them to God and to myself?" The best answer to those questions is the experience of doing it, but that answer will not allay the anxieties of the questioner. We have already mentioned the deep sense of well-being we experience from acceptance by another human being, and that is a big part of the answer to this question. But there is more, and it has to do with helping ourselves to get through our own self-deceptions. Most of us are so adept at fooling ourselves—at hiding the cold, hard, objective truth about ourselves from ourselves, at sugar-coating it or softening it (we have had to be good at this to avoid the pains of shame, guilt, and self-worthlessness we would have suffered without these self-deceptive skills)—that we need outside help to see where we might be continuing our self-deceptions. We need another viewpoint—an unbiased, unaffected, understanding, accepting, nonjudging, noncondemning viewpoint. It is one thing to be honest with ourselves, but how can we be sure if we have only ourselves to check with?

Since our Higher Power is generally a private matter with each of us, we may admit our wrongs to Him/Her, but still hold back or are not completely honest without realizing it. Only another human being can provide us with a valid checkpoint—not only a test of our humility, as we have said, but a test of our honesty as well. By providing a sympathetic ear, by gently questioning or asking us to clarify certain points, perhaps by sharing a similar (or worse) experience with us, another human being can encourage greater honesty on our part, and lead us to discover within ourselves additional self-deceptions we may have overlooked. This is a function very few of us can fulfill for ourselves.

The beauty of this honest discussion of ourselves with an-

other human being is that, having done it, the "horror" value or shame value of our past wrongs and present character defects seem to diminish at an amazing rate. We find ourselves much more willing to own up to our shortcomings, to discuss them openly with increasing numbers of people; in short, to stop hiding. We become more real, more genuine, more true. To paraphrase one author, we reach a point where we say, "Okay, Baby, I may not be as much as I thought I was or would like to be, but I'm all I've got, and that's okay. That's a good place to start from and to build from."

Step One
We admitted we were powerless over our emotions — that our lives had become unmanageable.

Step Two
Came to believe that a Power greater than ourselves could restore us to sanity.

Step Three
Made a decision to turn our will and our lives over to the care of God, as we understood Him.

Step Four
Made a searching and fearless moral inventory of ourselves.

Step Five
Admitted to God, to ourselves and to another human being the exact nature of our wrongs.

Step Six
Were entirely ready to have God remove all these defects of character.

Step Seven
Humbly asked Him to remove our shortcomings.

Step Eight
Made a list of all persons we had harmed, and became willing to make amends to them all.

Step Nine
Made direct amends to such people wherever possible, except when to do so would injure them or others.

Step Ten
Continued to take personal inventory and when we were wrong, promptly admitted it.

Step Eleven
Sought through prayer and meditation to improve our conscious contact with God, as we understood Him, praying only for knowledge of His will for us and the power to carry that out.

Step Twelve
Having had a spiritual awakening as the result of these steps, we tried to carry this message to others, and to practice these principles in all our affairs.

Step Six

Having gone through Step Five, we have completed the first part of our initial housecleaning and, in doing so, may have come a long way toward being entirely ready to have God remove all our defects of character. However, to many of us Step Six looks almost too simple. Of course, we are ready to have our character defects removed. This is what we have been trying to do all our lives—to be perfect! Who wants to be saddled with selfishness, self-centeredness, resentments, anxieties, fears, and all the rest? Our most fervent wish is to have all of these removed. But few of us realize until we have gone through the prior steps that wishing or wanting to have our character defects removed does not automatically make us ready to have them removed. Even asking God to remove them, as we do in Step Seven, will not help if we are not ready. What does being ready mean, then? When are we ready? And how do we know we are ready?

To answer these questions, we are brought back once again, as we always are in the Program, to the fact that each of us is unique. We must all seek our own individual way to become ready and must travel that path in our own time. While doing that, however, we might bear in mind the following.

Perhaps the most essential ingredient of our readiness is our old friend humility. Going through Steps One through Five has required an ever increasing humility on our part. But at Step Six we find our humility must grow some more to have our character defects removed. We must really relinquish our egos; we must truly seek God's will for us and relinquish our own. Another way to say this is that we must truly listen to our inner voices, our intuition, the voice of our unconscious, rather than blot out these inner messages with the conscious thoughts, rationalizations, "shoulds and oughts and wants" of our rational mind. For God's guidance really comes from our inner spiritual core, and, to hear it, we must listen inwardly.

"Being entirely ready to have God remove all these defects of character" also means that we must be ready for freedom. For without our defects to fall back on, without our faults to blame ("I can't help it, that's just the way I am"), there are no more restraints to freedom. We become free to choose, free to act, free to be; and we are left with the total responsibility for our attitudes, feelings, and behavior in the existential sense. We become our own person—free to live the life we choose as we choose it. It may seem to some that we are not entirely free since we have chosen God, but that is not so. Since God is infinite and imposes no limitations on us, we are truly free. We have chosen God for our own well-being and for that of others; in short, for the development and growth of our spiritual selves, and thus of the entire universe. So we must be ready for this freedom because, at first, when we are not accustomed to it, it is frightening. But if we remember that fear is inversely proportional to faith in our Higher Power, then, as our faith has grown through the first Five Steps, our fears have been greatly reduced, thus making us increasingly ready to have our defects removed.

Lastly, we need to examine the working of the Sixth Step's *"entirely ready"* and *"all* these defects of character" which make the Step sound as though at a single point in

time we become completely and absolutely ready to have *all* our defects removed at once. For some people it may actually happen this way—like a thunderbolt. They become ready; they ask God to remove all their shortcomings (Step Seven), and they (the shortcomings) are gone! These people experience a sudden spiritual awakening; they are, in fact, reborn in the sense that Buddha was reborn when he woke up. Emotionally and spiritually, these people are new persons.

For most of us, though, the process is slow and gradual. As we continue to take Fourth and Fifth (or as we take our Tenth) Steps after our initial ones, and as we try to apply and live the principles of the Program in our daily lives, we find that we gradually and sequentially become ready to have our defects of character removed. For some defects, this is easier than others, and of course, for the easy ones, we will be ready sooner. What often happens to many of us is that we are not consciously aware of being ready to have one or more defects removed, or even of asking God to remove them. The first conscious awareness we have is that we are different somehow. We have changed. Often the change is noticed by others close to us before we even become aware of it ourselves. The fear-ridden person begins to function more adequately; the power addict becomes warmer and more compassionate; the insecure neurotic no longer nags or criticizes other people, has a more positive attitude, and speaks constructively and with more confidence. The depressive neurotic's depressions occur less often, last for briefer periods, and are much less intense. Nearly all practitioners of this Program become calmer, more serene, and they wear genuine smiles much of the time. Through these examples, which are the rule rather than the exception in the Program, we see that much of the "work" of the Program is done unconsciously, without conscious action on our part. This seems to be especially true about Step Six, and often Step Seven.

By merely attempting consciously to live the Program

principles, prayers, and slogans (which we call "doing the footwork"), we unconsciously become ready to have God remove our defects of character. Our willingness to have them removed is an unconscious request which He hears just as well as if we had consciously phrased the request in a verbal and audible prayer. We have said earlier that God understands all languages including, or especially, that of the heart, and we might now add that of the unconscious. This fact, which we have observed countless times in ourselves and others in this Program, lends credence to the belief many of us hold that God resides within our unconscious and that we are all interconnected through a "collective unconscious."

This phenomenon of our desires or wishes being granted through our unconscious is described in detail in a book called *Psycho-Cybernetics* by Maxwell Maltz. He calls this phenomenon of unconscious feedback by a fancy scientific name; we call it by an older more familiar one, God. The point is, of course, that it does not matter what we call it as long as we practice it, and this Program of spiritual development helps us to practice it continually.

For some of our tougher, more deep-rooted defects, the unconscious may not be enough. Our active conscious help will most likely be required. We can provide this help by gently reminding ourselves to adopt the same observing attitude we mentioned in Step Four. By becoming observers of ourselves, we can increase our awareness of how we act or react in various situations. When we see ourselves doing anything which is not constructive and which we wish to change, or thinking negative thoughts, we take note of it and remind ourselves that these are old ideas, thoughts, or acts which we wish to let go. We presently replace these with more constructive ideas, thoughts, or acts. If we have trouble doing that, we ask our Higher Power for help and for the willingness to be helped, if necessary. And we continue to ask humbly until the undesirable thought is out of our minds, or until the negative feelings have gone.

This technique of observation, awareness, and replacement will work only if we have first taken a thorough inventory and come face-to-face with the mean, selfish, and perhaps even cruel parts of ourselves; if we have admitted to ourselves, to God, and to another person all of the things the destructive parts of ourselves have done in the past to hurt others and ourselves; and if we are now trying our best to accept and forgive those parts of ourselves. For it is only when we fully and humbly accept them that God seems to be able to change or remove them.

Step One
We admitted we were powerless over our emotions — that our lives had become unmanageable.

Step Two
Came to believe that a Power greater than ourselves could restore us to sanity.

Step Three
Made a decision to turn our will and our lives over to the care of God, as we understood Him.

Step Four
Made a searching and fearless moral inventory of ourselves.

Step Five
Admitted to God, to ourselves and to another human being the exact nature of our wrongs.

Step Six
Were entirely ready to have God remove all these defects of character.

Step Seven
Humbly asked Him to remove our shortcomings.

Step Eight
Made a list of all persons we had harmed, and became willing to make amends to them all.

Step Nine
Made direct amends to such people wherever possible, except when to do so would injure them or others.

Step Ten
Continued to take personal inventory and when we were wrong, promptly admitted it.

Step Eleven
Sought through prayer and meditation to improve our conscious contact with God, as we understood Him, praying only for knowledge of His will for us and the power to carry that out.

Step Twelve
Having had a spiritual awakening as the result of these steps, we tried to carry this message to others, and to practice these principles in all our affairs.

Step Seven

In case we think that by the time we reach Step Seven, we have acquired quite enough humility, the very first word of the Step reminds us that we have not. But by this time, for most of us, humility has become a quality to be sought, not to be shunned. Our experience in the Program has changed our attitude toward humility completely. Like almost everyone else in this world, we used to think of humility as depreciating our worth, robbing us of our self-confidence, and requiring us to grovel in the dirt in self-abasement. Most of us confused humility and humiliation. We tried to avoid both like the plague. We could have none of that, for it would paralyze us—render us helpless, powerless, unable to function.

But as we practiced the Program to the best of our ability, as we listened and learned from others, as we began to emerge slowly from our neurotic fog, it started to dawn on us that we had things exactly reversed. Humility did not deflate our egos; but when we saw that our overinflated egos were causing us all kinds of pain and grief, and we decided to deflate them or release them with the help of our Higher Power, then we acquired some measure of humility. Often,

it was the humiliation we suffered repeatedly as a result of our inflated egos which eventually brought us to the point of accepting humility, or accepting the things we cannot change with humility and serenity. We found that there could be no serenity for us without some degree of humility. As long as our egos were still in there fighting to change things we could not change, we were butting our heads against the proverbial wall with the inevitable result of a bloody head, a bruised ego, and a new humiliation. For some of us, that is the only way to learn; and we must learn some lessons again and again before we are ready to accept their content. Our own finite egos are limited; our own will creates havoc all around us; only through our unlimited Higher Power can we achieve the serenity we seek. When we finally understand this, we are ready for Step Seven.

We desire humility not only because it is necessary to ask for God's help in removing our shortcomings, but because we have realized that it is the only way to achieve the serenity, calm, and happiness we seek. To restate this, if we desire to be a maturing, growing, expanding, useful, joyous, happy person, we will have to develop an inner calm or serenity—even in a turbulent, insane world. To achieve this inner calm, we must develop humility—the ability to accept things as they are when we cannot change them, and to seek God's help in changing the things we can. And before we can develop from the humility required to admit we are powerless (Step One) to the humility required to humbly ask God to remove our shortcomings (Step Seven), we must clean house; we must identify these shortcomings as in Step Four, admit them to God, to ourselves, and to another human being, and we must become entirely ready to have them removed. Only then can we come to know humility as a desirable quality.

Like Step Six, Step Seven implies removal of *all* our shortcomings, though the word "all" is not included. Again, it must seem too easy to the newcomer to the Program to merely have to ask God for the removal of shortcomings to

have them removed. Here again we make the point that we do not "merely" ask; we "humbly" ask, and the development of the humility necessary for this has been the business of the first Six Steps. Moreover, though Step Seven implies removal of all our shortcomings, we must remember to deal with each one *individually,* preferably beginning with the easier ones to build confidence as we go. We cannot expect too much of ourselves. Nor can we realistically expect to accomplish our improvement all at once, nor without the help of our Higher Power. We need to remind ourselves as often as necessary to accept God's help in all our affairs. We may have to ask Him over and over again to help us surrender our most troublesome and ingrained shortcomings. The important thing is to keep trying gently, and progress will come at our own inner pace.

Though miracles can and do happen, we *cannot expect them* or command them. For we do not order miracles—a form of expectation—rather, God causes them for us when we are ready for them and for Him. If we ask God to remove a defect of character and it is not removed, we need not be discouraged, or become angry at God or at ourselves. For if we do, we would be angry at God for not doing our bidding, and by now we know that is not the way the Program works. If a shortcoming is not removed when we ask God to remove it, it simply means *we* have more work to do. We are not yet entirely willing to have it removed, though we may consciously think we are; or we have not asked *humbly.* This does not mean that God is punishing us, and that the shortcoming will *never* be removed; it merely means we must go back and work a little longer on one or more of the earlier Steps.

But it may also mean something else; it may mean that we have asked God to remove a shortcoming, and then we have sat back and expected Him to do it all by Himself. After all, we say, "You are all-powerful God, so please go ahead and remove it!" Not only is this type of "request" not humble, but even if it is asked in all humility, we must still

do some "footwork." We must do all we can to cooperate with God in eliminating the shortcomings we have asked Him to remove. We must demonstrate our complete willingness on an ongoing basis. We must give our *full* consent. We cannot expect our shortcomings to be removed if we continue to behave exactly as we did while "waiting" for God to do it all for us. For if we do this, it means we are not truly (unconsciously) willing to have our deficiency removed and we are not yet humble enough. We are still unconsciously hanging on—unwilling to let go. This often happens to many of us. It is only one more indication from our unconscious that we are human. Again, the important thing is to keep trying *gently*. We may be helped in this by remembering that we are neither saints nor God.

If we are willing to grow spiritually and emotionally, and if we can see even a little progress as we proceed, that is enough cause for gratitude and joy. And our "attitude of gratitude," as our good friend Edythe constantly reminds us, is a bonus that helps us not only to feel better, but to grow a little faster too. We also need to remember that this process of spiritual development is lifelong, yet we practice it one day at a time—or one minute at a time, if necessary.

Step One
We admitted we were powerless over our emotions — that our lives had become unmanageable.

Step Two
Came to believe that a Power greater than ourselves could restore us to sanity.

Step Three
Made a decision to turn our will and our lives over to the care of God, as we understood Him.

Step Four
Made a searching and fearless moral inventory of ourselves.

Step Five
Admitted to God, to ourselves and to another human being the exact nature of our wrongs.

Step Six
Were entirely ready to have God remove all these defects of character.

Step Seven
Humbly asked Him to remove our shortcomings.

Step Eight
Made a list of all persons we had harmed, and became willing to make amends to them all.

Step Nine
Made direct amends to such people wherever possible, except when to do so would injure them or others.

Step Ten
Continued to take personal inventory and when we were wrong, promptly admitted it.

Step Eleven
Sought through prayer and meditation to improve our conscious contact with God, as we understood Him, praying only for knowledge of His will for us and the power to carry that out.

Step Twelve
Having had a spiritual awakening as the result of these steps, we tried to carry this message to others, and to practice these principles in all our affairs.

Step Eight

When we took our inventory in Step Four, we made a list of all people we had harmed over the years. We may now wish to update and complete that list. To continue our internal housecleaning, we must become willing to go to these people whenever possible, and repair the damage we did in the past. If our inventory was not thorough enough, we may need to go back through Steps Four through Seven before proceeding with Step Eight. We may have to go back through the first three Steps as well, if we hit a snag in making the inventory truly honest, fearless, and thorough. For most of us, even those who have lightning-bolt-type spiritual awakenings at Steps One, Two, or Three, the Program is gradual. We cannot change in a week, a month, or even a year what has taken twenty to forty years or more to build up. We cannot remake the present until we undo the past, and the past can only be undone gradually. We must repeat each Step over and over, each time with increasing honesty, humility, and thoroughness. So our list may not be complete. We may need to add to it.

But having or making a list is only the first part of Step Eight. The second part, "became willing to make amends"

to all the people on that list, may well prove the most difficult for many of us. It is one thing to admit our faults to ourselves, to God, and to another impartial human being, but now we are asked to be willing to talk directly or write to people we have harmed, express our regrets sincerely, and make restitution for any physical or monetary damage we may have caused them. This means fully and completely acknowledging our part of every dispute in which harm came to someone as a result of our action or inaction, regardless of cause, and no matter how justified we may have felt. Justification does not enter into it, for that only leads us away from our own wrongdoing or part of the feud to the other person's. And acknowledging or apologizing for anyone else's wrong never did us much good. Only by expressing genuine regret for *our own part* in the dispute and for the harm or injury we caused the other person, can we complete our housecleaning to the point necessary for the further spiritual development we need to attain and maintain serenity and joy.

Whereas Steps Four and Five were our own personal housecleaning, Steps Eight and Nine are our social housecleaning—getting rid of the guilt caused by the knowledge, conscious or unconscious, that we have harmed other people. But before we can clean house by making amends (Step Nine) we must become *willing to do it*. This may sound easy, and we may think that "of course, I'm willing," but it often is not, as we find out when we get to Step Nine. Becoming willing to make amends requires two things: first, that we become willing to forgive, and second, another large dose of—you guessed it—humility.

In working through Steps Four through Seven, and listening to many people at meetings and to our sponsor, we have already become aware that resentments and grudges are luxuries we cannot afford. They not only are destroyers of our serenity and often our sanity, but they are more harmful to us than to the person we resent. A resentment or grudge is like an open sore eating away at our insides, making us

grouchy, bitter, ill-tempered, unable to concentrate on growth because our attention is continually focused on the grudge or resentment, or it is riveted to the person, place, situation, or institution we resent. The resentment may provide its own temporary relief for the pressure it builds up inside us, but the pressure never lets up, never disappears, no matter how often it is relieved, until we learn to release the resentment through acceptance and forgiveness, and turn it over to our Higher Power as Step Three suggests we do.

We need to recognize that by losing our cool, we frequently harmed ourselves more than others. When confronted with a guilt or other shortcoming we did not want to face, we struck out at anyone near us rather than honestly look at ourselves. Sometimes the other person understood this and refused to be harmed by our outbursts. In these instances we hurt only ourselves through our own uncontrolled and dishonest behavior. Even in those cases we must become willing to make amends, for we do not know for sure whether the other person was harmed or not. The point is that we behaved badly, and must make amends for that wrong if we wish to continue to grow.

When we begin to understand the damage we did to ourselves, we need to make amends by forgiving ourselves and trying to learn from our experience to reduce our likelihood of repeating it in the future. In every case in which we have harmed ourselves, it is as important to forgive ourselves as it is the other person. If we do not forgive ourselves, we cannot forgive others, and if we do not forgive others, we cannot make amends with dignity and self-respect, and without humiliation. If we have not forgiven, if we still hold grudges, our amends can easily degenerate into a new argument or dispute. This is why our willingness to make amends must stem from a true desire to forgive and forget the other person's wrong as well as ours.

This need to forgive is the reason this step requires more humility from us. So far we have had the humility to surren-

der, to accept the will of our Higher Power instead of our own in many areas, to take an honest, searching look at ourselves and admit what we found to God and to another person. We have had also the humility to become ready and then to ask God to remove at least some of our character defects. We are now at the point where we must develop the humility to forgive friend and foe alike—and to love our enemies, as Christ advised.

With this degree of humility, we can truly see each and every human being, whether close to us or not, whether or not we agree with or understand that person, as having the same rights to be here and live happily on this earth as we do. We can cease viewing disagreements as threats to our egos or our well-being. We can begin to respect opinions different from our own without the need to deprecate them or the person holding them. We can recognize that all viewpoints are needed and are important to someone. This does not mean we have to agree with everyone about everything, but it does mean that we can stop hating someone or being condescending because his or her views are different from ours. It also means that our own sanity will be preserved and our serenity greatly enhanced if we can forgive and even love our enemies, rather than hate or wish them harm.

For most of us, forgiving, although difficult at first, is much easier than loving an enemy. If we are truly honest, objective, and sufficiently humble, we can forgive an enemy, but loving someone we feel is doing us harm requires a great deal of spiritual development—almost to the point of sainthood. But if we think of it in different terms, it may not be so difficult. We have often heard it said that each one of us is his or her own worst enemy, or in the famous words of the comic strip character Pogo, "We have met the enemy, and he is us!" Yet we have repeated throughout this book, as many authors have before us, that if we do not love ourselves, we cannot love anyone else. If we put these two truths together, we come to the conclusion that we must learn to love the enemy within us if we want to lead a happy,

serene life and continue to grow spiritually and emotionally.

As we proceed through the Steps of this Program, we do indeed learn to forgive, and like, and then love the enemy within, and through that process, that enemy becomes less of an enemy. As we learn to recognize our inner enemy and to develop greater acceptance rather than belligerence and rejection toward that part of us, it loses much, if not all, of its ability to hurt us, to block our way to progress, and to hinder our growth and development. The enemy within does not necessarily disappear, but we learn to recognize when that enemy is active and to turn our negative, destructive attitudes into positive, constructive uses. We can apply exactly the same process to our enemies without. As we forgive them, they seem and act less like enemies. As we learn to like and love them, they may often become fast friends. Step Eight may be the burgeoning of many a friendship. In Step Nine, they may burst into full bloom.

Step One
We admitted we were powerless over our emotions — that our lives had become unmanageable.

Step Two
Came to believe that a Power greater than ourselves could restore us to sanity.

Step Three
Made a decision to turn our will and our lives over to the care of God, as we understood Him.

Step Four
Made a searching and fearless moral inventory of ourselves.

Step Five
Admitted to God, to ourselves and to another human being the exact nature of our wrongs.

Step Six
Were entirely ready to have God remove all these defects of character.

Step Seven
Humbly asked Him to remove our shortcomings.

Step Eight
Made a list of all persons we had harmed, and became willing to make amends to them all.

Step Nine
Made direct amends to such people wherever possible, except when to do so would injure them or others.

Step Ten
Continued to take personal inventory and when we were wrong, promptly admitted it.

Step Eleven
Sought through prayer and meditation to improve our conscious contact with God, as we understood Him, praying only for knowledge of His will for us and the power to carry that out.

Step Twelve
Having had a spiritual awakening as the result of these steps, we tried to carry this message to others, and to practice these principles in all our affairs.

Step Nine

In taking Step Eight, we made our list; we considered the harm we had brought to each person on it; and we became entirely willing to make amends to *all* these people and to make restitution whenever we could. In Step Nine, it is suggested we go to each person on the list, and wherever possible, make direct amends, providing this does not hurt them or others. To do this with humility requires great courage on our part, which at first we may fear we lack. But if we remember that the lack of courage is fear, and that by this stage of our progress, we have replaced a great many of our fears with faith, then the courage will come to us. All we need do is continue sincerely and humbly to ask our Higher Power for it, and eventually, when we are truly ready, we will find that we have the courage we need to do the job.

Step Nine also tells us that we need to use reasonable caution in making amends. Even when courage comes, we cannot rush about brashly reopening old wounds or exposing dirty linen which might hurt the person to whom we are making the amends or a third party. One example given in Program literature is that of a husband who has had one or more extramarital affairs in the past and now wishes to

make amends. The suggestion is that if his wife is unsuspecting of these affairs—probably a rare case—finding out about them now would unnecessarily hurt her. In this case, the husband had best keep his direct amends to himself and instead make amends indirectly by changing his behavior, concentrating more of his affection on his wife and honestly trying to rebuild an undoubtedly deteriorated marriage relationship.

In the more frequent case where the wife is aware of the husband's errant ways, direct amends may be best, but without naming or involving third parties whose reputations might suffer if their identities were revealed. Even in this case, if the wife is likely to be inquisitive and demanding about the identities of the other woman or women, it may be best to withhold direct amends to avoid unnecessary injury to those women. No single answer can fit all such difficult situations. In these or many other cases involving serious consequences such as potential loss of employment, imprisonment, or other harm to one's family, each one of us has to make decisions on an individual basis, perhaps after consulting our Program sponsor, a close friend or relative, our clergyperson or spiritual advisor. The important thing to bear in mind is that we should not be deterred from making amends by fear for ourselves, but only by the real possibility of injury to others. We will only have to suffer later for any "excuses" we make for ourselves at this point. Our lack of candor or courage or willingness at this or any other point in the Program will either delay our growth or prevent us from growing further. Or, if severe enough, it will cause us to regress, become emotionally sicker, and, if continued, start us once more on the road to insanity, whence we have recently come.

Occasional emotional or spiritual relapses, or "slips" as they are called in the Program, are to be expected, and not to be confused with the permanent regressions they could grow into if we do not see them at the start. As the Program constantly reminds us, none of us is a saint. No program of

emotional and spiritual development can be expected to be a unidirectional road with never a reversal. We can all expect temporary reverses in our steady improvement, and after a while learn to recognize these as signals that we are forgetting something. Perhaps we have started to take part of our will back from our Higher Power and must go back to Step Three; or possibly we have inadvertently left out an important part of our inventory and must go back to Step Four; or though our inventory has been thorough and all is there in black and white, we have one or more character defects we are too fond of and cannot let go, so we must go back to Step Six.

In fact, the entire Twelve Step Program is one of constant repetition and gradual improvement. Most of us need to go over each of the Steps over and over again as we continue our growth process throughout our lifetimes. After the first time, the Steps need not be repeated in order, but as we grow, we are able to face more of ourselves. As we discover and uncover new facets of ourselves, both good and bad, through living our daily lives, we need to apply one or more of the suggested Steps to keep ourselves and our lives in perspective and on the way toward greater spiritual development.

With our initial execution of Step Nine, we complete the personal housecleaning phase of this Program. The words of the "Big Book" of AA best express what we can expect at this point or even before. These are called the Twelve Promises of the Program:

> If we [have been] painstaking about this phase of our development [Steps Four through Nine], we will be amazed before we are halfway through.
>
> We are going to know a new freedom and a new happiness.
>
> We will not regret our past nor wish to shut the door on it.

We will comprehend the word serenity and we will know peace.

No matter how far down the scale we have gone, we will see how our experience can benefit others.

The feeling of uselessness and self-pity will disappear.

We will lose interest in selfish things and gain interest in our fellows.

Self-seeking will slip away.

Our whole attitude and outlook upon life will change.

Fear of people and of economic insecurity will leave us.

We will intuitively know how to handle situations which use to baffle us.

We will suddenly realize that God is doing for us what we could not do for ourselves.

Are these extravagant promises? We think not. They are being fulfilled among us—sometimes quickly, sometimes slowly. They will always materialize if we work for them (*Alcoholics Anonymous,* pp. 83-84).

Step One
We admitted we were powerless over our emotions — that our lives had become unmanageable.

Step Two
Came to believe that a Power greater than ourselves could restore us to sanity.

Step Three
Made a decision to turn our will and our lives over to the care of God, as we understood Him.

Step Four
Made a searching and fearless moral inventory of ourselves.

Step Five
Admitted to God, to ourselves and to another human being the exact nature of our wrongs.

Step Six
Were entirely ready to have God remove all these defects of character.

Step Seven
Humbly asked Him to remove our shortcomings.

Step Eight
Made a list of all persons we had harmed, and became willing to make amends to them all.

Step Nine
Made direct amends to such people wherever possible, except when to do so would injure them or others.

Step Ten
Continued to take personal inventory and when we were wrong, promptly admitted it.

Step Eleven
Sought through prayer and meditation to improve our conscious contact with God, as we understood Him, praying only for knowledge of His will for us and the power to carry that out.

Step Twelve
Having had a spiritual awakening as the result of these steps, we tried to carry this message to others, and to practice these principles in all our affairs.

Step Ten

Having completed our initial housecleaning which is essential to further spiritual development, we are now ready for the maintenance, sustenance, and growth phases of the Program—Steps Ten, Eleven, and Twelve. We have said that spiritual development is a lifelong process; a number of us believe that it continues beyond our current lifetime, but that is an entirely individual matter.

The Twelve Step Program outlined here is a lifelong program practiced by most of us on a daily basis, one day at a time. This assertion may irk those who think of education or development as a one-shot deal. We go through twelve or sixteen or twenty years of schooling; then we're done. We go to the doctor to be treated, and when the symptoms of the disease are gone, we're cured. Or we go to a psychiatrist for one or five or ten years, and then we're well. Actually, just as we never finish our intellectual education and our emotional development, we never complete our spiritual development either. Though we can kid ourselves that we are finished, all of these growth processes are open-ended. They continue as long as we are willing to let them. We certainly can and do arrest them, but only at the risk of dying prema-

ture deaths at least spiritually and emotionally, and often physically as well; or of living long but dull or miserable lives.

Many of us are complacent—we want only enough emotional and spiritual development to make us reasonably comfortable—then we say: "Enough! Now, I can relax." We stop going to meetings. All kinds of other activities come up to interfere with our meeting times, and these all seem more important than Program meetings. Or we are too tired to attend meetings; it is too far to drive. Or else we begin to be critical of meetings; they don't do for us what they used to; they're becoming humdrum, boring, repetitious; we've heard it all a thousand times and "know" it by heart. All of us have been through periods like these, which often continued for weeks or months. Some of us dropped out completely. But those of us who did eventually noticed that we didn't feel as well as we used to; we were becoming irritable, short-tempered, and negative in our attitudes as we once had been. Some of us might even develop a depression or two, or some new physical symptoms might crop up or old ones might flare up again.

We then began to wonder if perhaps these new threats to our serenity and sanity might be the result of our missing meetings, of not practicing the Program on a daily basis— and most of all of having slipped in our self-honesty. We weren't sure and did not want to believe this, but decided to find out. We went back to a meeting—and the warmth, enthusiasm and joy with which we were greeted by our old friends with never a criticism about staying away, were enough to tell us immediately that we had waited too long to come back. The emotional and spiritual uplift we felt during the meeting erased a large part of the negative slump we had sunk into—and we knew we were back on the track, traveling once again toward greater spiritual development and ensuing sanity and serenity.

We find that it is extremely difficult to "rest on our laurels" in this Program. If we try it, not only do we start slip-

ping backwards, but once we have contacted the inner energy which propels us toward God or toward our divine self, it is difficult if not impossible to ignore it. We constantly feel a soft, gentle inner force impelling us to continue—to develop further, to grow spiritually—one day at a time—beyond all imaginable boundaries.

To understand our continuing need for spiritual development, it may help to draw an analogy between spiritual development and eating. Just like food for our bodies, spiritual development must be replenished and supplemented every day of our lives. If we do not put food into our bodies several times each day, our stomachs let us know about it in no uncertain terms. Since we are a physically/materially oriented society, we have learned to be overresponsive to the hunger messages from our stomachs; we overeat. In the same way our bodies often signal to us the need for spiritual nourishment, but not being spiritually oriented, we ignore these messages or interpret them as something else.

Ulcers, colitis, skin eruptions, and many other ailments may be viewed as such signals. We hear more and more these days about psychosomatic illnesses. More doctors are attributing many diseases to psychological or emotional causes. Holistic medicine is gaining increasing recognition. We may now begin to see the relationship which exists between our body and the spiritual part of ourselves. With sufficient spiritual development, we begin to have more options for ourselves than developing ulcers, for example. With sufficient spiritual development, we see that we must take care of ourselves not only materially with food, money, and physical comforts, but also emotionally and spiritually on a daily basis. We begin to appreciate and love ourselves as whole human beings. We begin to be able to discriminate between short-lived limitations which may provide us with temporary emotional thrills, and more permanent spiritual and emotional nourishment which contributes to our long-range growth. We are no longer compelled to place ourselves in situations where the stress will be so high as to

cause ulcers or other diseases; or, if we cannot completely avoid such situations, we can face them with sufficient serenity so that the ulcer or illness does not develop. With the help of our Higher Power we are able to let go and let God so that the stress on us is minimized. Through the practice of the first nine Steps, we came slowly to the realization that we need our daily spiritual nourishment just as we need our physical nourishment. And that is what Steps Ten, Eleven, and Twelve are about. The daily practice of the Tenth Step maintains our honesty, without which we cannot have humility, without which we cannot have the daily spiritual nourishment we need for ongoing development.

The Program suggests three kinds of ongoing inventories. The "spot check" inventory is a frequent short review of our actions, thoughts, and motives taken several times a day as the need arises in our activities and interactions with others. Its main purpose is to provide us with a continuing awareness of ourselves on a moment-to-moment basis, so that we may maintain both the honesty so necessary to the sustenance and growth of humility, and the freedom from guilt which we have acquired by practicing Steps Four through Nine.

Since guilt is one of the great blocks to spiritual development, we must remain free of it if we wish to continue to grow and to avoid regression into insanity. The way we remain free of guilt is *not* by the saintly or God-like behavior of never commiting any wrongful acts—since we are neither saints nor God—but by taking frequent inventories, and when we find we are wrong, by promptly admitting it. We do not tell the truth and admit our wrongs for the sake of others, as most of us are taught as little children, but for our own sake—to maintain our sanity and our serenity, and to continue our development process with minimum delay.

Many of us who take frequent "spot check" inventories feel that we are doing enough—we do not need the additional daily ones suggested in the Program. But these daily

reviews of an entire day's activities, usually done at day's end just before going to sleep, serve different and complementary purposes. For one thing, they remind us that this is a daily Program, lived one day at a time. The daily inventory keeps us focused on today and tends to prevent us from worrying about the future and recriminating over the past. A daily inventory, taken honestly and objectively, reminds us every day that what counts is today. We take these inventories much the same way as we did in Step Four, except that we now cover only one day instead of our entire past lives. We try not to judge our actions or motives too harshly, but if we must judge at all, we try to not condemn or punish ourselves. We admit our wrongs, but sentence ourselves only to make amends, if necessary, and to try to do better next time. We remember that progress is not made by punishment but by love, since punishment brings fear, resentment, and revenge, whereas love brings acceptance, cooperation, and joy. This statement holds for our attitude toward ourselves as well as toward others.

The impartial observer attitude we discussed previously can be very helpful here too. We observe ourselves as if we were reviewing someone else, and try to complete our review before we start evaluating. Our "third party" role makes us more objective about ourselves, since our defense mechanism makes it easier to see faults in others than in ourselves. This role also helps us be more lenient with ourselves, since, by the same token, it is easier to accept faults in others than in ourselves. When the review is complete, we evaluate it, and when we find we are wrong, or even partially wrong, we promptly admit it. If amends are necessary, we make them the very next day if possible, unless it might harm someone else.

Another advantage of the daily inventory as a supplement to the "spot check" is that the latter is usually a "quickie" done on the run. We often do not have time during the day to find the true motive behind a certain action. We can remedy this by doing our daily inventory in a calm

way in a quiet place, where we do not feel rushed by the press of events or demand for our services. Many of us find doing it in bed, just prior to dozing off, very refreshing and conducive to a good night's sleep with a clear conscience.

In addition to the "spot check" and the daily inventories, the program suggests longer-term periodic ones. Again, these may seem superfluous if we are rigorous about our daily ones, but the main advantage of the longer-term ones is that they give us a chance to examine our spiritual progress from a better perspective. It is usually quite impossible for us to see any progress in ourselves on a day to day basis, especially since we all have emotional and spiritual ups and downs. But on a longer term—six months or a year—we can usually see remarkable changes, if we stop to look. We find that we are no longer anxious about a number of things that troubled us at the time of our previous inventory. Our spiritual and emotional understanding has expanded considerably. We may have started doing some things that we had thought about for years and continually put off because we thought we could not do them and were afraid to try (e.g., writing this book).

This progress based on honesty, humility, and a belief in a Higher Power, invariably gives us a great deal of satisfaction unequaled to any we have experienced before. But we must also be on our guard that it does not reinflate our egos or rebuild the false self-confidence we had before, confidence based on self rather than on God. We do this by always remembering who we are, where we come from, and the fact that if we stop practicing and trying to live this Program, we will end up right back down in that same hole again.

Our long-term inventories also give us a chance to spot problem areas that we have been working on for a considerable period of time, without making much headway. By becoming more conscious of these, we can concentrate our attention on them, review what we have done, try to determine why it has not worked, and ask God for new solu-

tions. Perhaps we are not yet ready to give up a certain defect to God; or perhaps in past inventories we have not yet become honest enough to identify the true motive; or possibly, we find some brand-new defects born of new experiences. If we are promoted in our work, for example, we may find the increased responsibility creates greater anxiety. We must come to terms with this and apply the principles of the Program to it as to all other areas of our lives.

First, we admit we are powerless over this anxiety. We know we cannot wish it away, hope it away, work it away, or get rid of it with alcohol, pills, or other drugs. By ourselves, we are powerless to do anything about it. Some of us may still be unconvinced of this and try all of the above methods, and some others as well; but eventually we all find we are powerless over this emotion as over all others. But we can seek the help of our Higher Power to assist us in coping with it. We can make a decision to turn this anxiety and our will about it over to the care of our God, as we understand Him. We can take an inventory about it. Why are we so anxious? Perhaps it is fear that we will not be able to perform the job, that we will not be able to exercise the judgment and make the decisions required of us. Or perhaps we are worried about loss of self-esteem and the esteem of others in case we are replaced, fired, or "kicked upstairs." Perhaps because of this anxiety, we have been short-tempered and irritable with our family at home and those around us at work.

We continue questioning ourselves in this manner until we are sure we have uncovered the real causes of the anxiety and all the harm we have caused. We then discuss all of this with another person whom we trust and try to become ready and willing to have the anxiety removed. To do this, we may have to adopt a whole new attitude about our job. We may come to realize that we may be placing too much importance there. True, we may need to earn a living to support our family, but must we do it on this particular level? We must ask ourselves with complete honesty

whether we feel qualified for this job. If the answer is no, perhaps we should consider becoming qualified through further training, education, or experience. All of these might reduce the anxiety we feel. If this anxiety is merely the "normal" amount nearly everyone feels when faced with a new situation, perhaps we are making too much of it. Possibly we should wait and see if it abates with time. We also need to be aware that the anxiety we feel, if too great, can be the very thing which impedes our performance, and our fears may become self-fulfilling prophecies. To make ourselves ready to have God remove these fears, we need to concentrate on today and on doing the best we can in this job today.

We must realize our fears are all about the future; we are worried about the *results* of our performance instead of concentrating our efforts on getting the best performance from ourselves we can today. This is often called in the Program "getting into the results department," and that is where we cannot afford to be. When we try to predict results or fear them, we are doing God's job. Our job is to do what we have to do *today* as best we can, and leave the results to our Higher Power. If we attempt to predict the outcome or to manipulate events to obtain an outcome in our favor, we are taking our will back and rejecting the help of our Higher Power. Perhaps we do not yet trust Him/Her enough, and need more work on Steps Two and Three.

If we sincerely want God to remove our anxiety about our job, then we must be willing to accept whatever outcome He decides for us. If His will is that we should not be in that job, then we will lose it no matter what we do, but if we are practicing our program, we will know that there is a reason why we have lost it—a lesson we must learn about ourselves which we could not learn any other way. If this happens, it is quite likely that God has something entirely different in store for us—a job more suited to our real talents, skills, capabilities, or personality than the one we have lost. If so, losing the job was a blessing in disguise. It was God's way of

90

guiding us to where we really want to be anyway.

Looking back over our lives, we can see many instances of such guidance, even when we were not ready to accept God's will for us. The only difference between now and then is that without the Program and a belief in a Higher Power, we saw many of these events as sufferings and misfortunes or as lucky coincidences—whereas now, when an unexpected change of this nature occurs, we realize that we must have been going down the wrong track, and that our Higher (Inner) Power is straightening us out.

When we are completely willing to accept the outcome of any action—whatever it may be—without worry, wish, expectation, or manipulating for our own outcome, we are then "entirely ready to have God remove" our anxiety or other defect. At that point, the anxiety disappears, often without making a "formal" request of God. He/She (our Inner Self) knows that we are ready, and acts without formal request from our conscious self.

Step One
We admitted we were powerless over our emotions — that our
lives had become unmanageable.

Step Two
Came to believe that a Power greater than ourselves could restore
us to sanity.

Step Three
Made a decision to turn our will and our lives over to the care of
God, as we understood Him.

Step Four
Made a searching and fearless moral inventory of ourselves.

Step Five
Admitted to God, to ourselves and to another human being the
exact nature of our wrongs.

Step Six
Were entirely ready to have God remove all these defects of
character.

Step Seven
Humbly asked Him to remove our shortcomings.

Step Eight
Made a list of all persons we had harmed, and became willing to
make amends to them all.

Step Nine
Made direct amends to such people wherever possible, except
when to do so would injure them or others.

Step Ten
Continued to take personal inventory and when we were wrong,
promptly admitted it.

Step Eleven
**Sought through prayer and meditation to improve our conscious
contact with God, as we understood Him, praying only for knowl-
edge of His will for us and the power to carry that out.**

Step Twelve
Having had a spiritual awakening as the result of these steps, we
tried to carry this message to others, and to practice these princi-
ples in all our affairs.

Step Eleven

As Step Ten guides our continued honesty to assure the progress of our emotional development, Steps Eleven and Twelve give us the tools with which to assure our continued spiritual development. Step Eleven suggests we try to improve our conscious contact with our Higher Power. It further suggests that we might do this through prayer and meditation, and thirdly, it suggests how we might pray. Many of us believe that our Higher Power is at least partly within us, and in some way is synonymous with our Inner Self, Higher Self, or Spiritual Center. This is God for those of us who understand Him in this way. If so, how do we communicate with this God? If God really is within us, He is within our unconscious, or within our superconscious, which is the "higher" part of our unconscious. If this is true, then unconsciously we are in communication with God at all times, whether awake or asleep, at work or at play, or in thought or meditation.

Many of us believe, however, that we have an enormous number of conscious, as well as some unconscious, barriers which keep us from being aware of this communication with our Higher Power. There isn't too much we can do

about the unconscious barriers. We had better leave those to our Higher Power. We find that if we try to work with the conscious ones, which we can do something about, our Higher Power takes care of the unconscious ones, though we may not know how He/She does this. The more skeptical of us will even be tempted to say that "they will take care of themselves." It may seem to us as though they take care of themselves; they break down or disappear, but in reality our Higher Power is working for us at all times. If we give our consent, He does this job for us without our being aware of it at all. We believe that our job is to remove our conscious barriers so that we may open a two-way communication channel with our Higher Power and consciously stop impeding His work at the unconscious level—in other words, so that we may communicate with our unconscious or superconscious. This two-way communication link is what Step Eleven is all about.

It is said in the Program that prayer is asking for God's guidance and meditation is listening for the answer. In terms of space-age terminology, prayer is the "up-link" from us to our Higher Power, whereas meditation opens the "down-link" through which we receive direction and guidance from our Higher Power. We are all familiar with the conscious barriers we spoke of above. They are our disbelief in God; our disbelief in the effectiveness of prayer; our feeling of foolishness when we pray or meditate, because we do not know if anyone hears us and feel we are talking to thin air; our hostility toward God because He allows cruelty and suffering to go on in the world; our feeling of our own weakness or meekness when we consider God, which goes against the image of strength so many of us build into our self-images; our belief that prayer and meditation are "useless" or "impractical" activities, or no activities at all, but a waste of time. We could name a million more of these conscious barriers. The key to breaking down these barriers, as we have already said numerous times, is willingness. "I won't" or "I can't" will break down nothing. It will only

make the barriers higher. "Maybe I can" or "I will try" will work miracles. It has for us. It can for you.

Let us assume we are willing. How do we go about it? How do we pray? How do we meditate? What do we pray for?

Most of us, if we were taught to pray at all, started with "Now, I lay me down to sleep and pray the Lord my soul to keep. If I should die before I wake, I pray the Lord my soul to take" before we even understood what the words meant. Perhaps we had a vague concept of God as an old man with a long white beard up in the sky somewhere, perhaps in some kind of fairy-tale palace behind beautiful pearly gates. Possibly just as vaguely, we knew a soul was something inside us, but weren't quite sure what. But Mommy and Daddy wanted us to say that prayer every night so that this vague God would love us, and so we did because we were expected to, or told to, or reminded to. And often we may have derived some sense of security from it, a sense of good feeling that all was right with the world, if we said our prayer—and that somehow when we said "God bless Mommy and Daddy" and possibly added a long list of relatives and friends at the end, that would mean that God would look after these people and keep them safe, so that we would be safe and secure and not left all alone.

But for many of us, that was not always so. In spite of our saying "God bless Mommy and Daddy," some mommies and daddies died, or went away and never came back. And, perhaps for some of us, that was the beginning of our doubts about God—the loss of a loved one, in spite of our requests to God to bless them and keep them safe. Perhaps in some deep, dark cranny of our unconscious we even felt responsible. Possibly it was we who had not prayed hard enough for God to hear us; perhaps God was "okay" after all, but we were not "okay." For many of us that might have been the beginning of a guilt we have lived with ever since—an artificial, fabricated guilt which nevertheless was a constant burden on our backs. Guilts such as these, and many others,

kept us from the emotional and spiritual growth we might otherwise have enjoyed.

But most of us soon graduated from our baby prayer to requests for material things. "God please let Santa Claus bring me a new bike for Christmas," or "God please let my blackheads go away." These personal or actually selfish requests could be endless. If they were answered, we were naturally encouraged and tried for bigger and better ones. Eventually they turned into demands, until they could no longer be answered, as self-centered demands never are, unless there is a lesson we must learn from getting what we pray for. As fewer and fewer requests and demands were answered, we became disenchanted with God. Either He had forgotten us because we were bad, we reasoned, or He did not exist at all. After all, Santa Claus wasn't real either. Why should God be any more real? And so the conscious barriers were built.

Many of us found fault with the Bible. After all, hadn't Darwin proved otherwise? And what about all that funny language in the Bible that no one could understand—all these "Thou"s and "Thy"s and "verily"s and "It came to pass"s? We couldn't be bothered. There were too many exciting things to do in life to spend much time thinking about some God who may not even exist. We obtained too much reinforcement from those around us—from our materialistic commercial/institutional environment—to ever really question whether we might have been praying in the wrong way. Everybody else was doing the same thing we were, so we must be right. Besides, how else could we pray? A prayer is a prayer is a prayer, we thought.

But Step Eleven suggests differently. It tells us to pray for two things and for two things *only*. The knowledge of God's will for us, and the power to carry that out.

How strange! Does God have a will for us after all? Does God care what we do? Has He really not forgotten us or forsaken us? Step Eleven is a direct follow-on to Step Three where we made a decision to turn our will and our lives over

to the care of God, as we understood Him. Since we have turned our will and our lives over to Him, we have no more will—at least no will to direct, manage, or guide our own lives or anyone else's. It is comforting to know that our Higher Power does have a will for us, and that He/She will "tell" us what that is, if we ask. But there's a catch. God will not tell us all at once. He will not say to us: "Now sit down over here, Joe or Jane, and I will give you a two-hour lecture on My will for you for the rest of your life." For most of us, He does not seem to work that way. One of the most important slogans of this Program, which we have already repeated several times, is "One day at a time."

It seems for us, that is the way we best live our lives, and that is the way we ask for God's guidance—one day at a time, every day of our lives. Therein lies the reason for daily or several-times-daily prayer. Not that we need a constant reminder of God, or that God demands homage from us, but that for our own sanity, serenity, and continued spiritual development, we need daily or more frequent guidance from our Higher Power—from our Inner Self. This is the way we break down the barriers of consciousness which keep us from communicating with our Higher Power, and make sure that, once down, they stay down.

We know, of course, that this suggestion of daily prayer is a part of every known religion. Muslims pray five times a day, wherever they may be. They merely spread out their prayer mats and recite the prayers specified in the Koran. If we have been, or still are, a member of a religious sect or church, the Program suggests that we might wish to return to it when we are ready. But whether we do or not is entirely our own affair and has nothing to do with the Program. Our experience tells us that we can pray as well at home, in church, in a crowded meeting room, or in a car. The important things to us are that we pray; that we pray daily or more frequently; and that when we pray, *we ask only to know God's will for us and for the power and courage to carry it out.*

The second part of this prayer is as important as the first. If we are to carry out God's will, we must ask for the power to do so—or else we will remain paralyzed, unable to act. In the First Step, we admitted we were powerless over our emotions, our compulsions, our addictions, and all our neuroses. In addition, most of us found that sooner or later, if we wanted this Program to work for us, we had to surrender completely, including all our power over people, places, and things, often including ourselves. We could not retain one iota of personal power because we did not know how to use it wisely or even effectively.

In Step Three we turned our will and our lives over to the care of our Higher Power, and again we found that eventually we had to turn *all* of our will and *all* of our lives over to the care of God, as we understood Him, because using our will ourselves, we could not manage our own lives to the real, long-term benefit of ourselves or anyone else. Being left then without power and without will, we are powerless to do anything without God's help, which is exactly the way we think it should be. Then in Step Eleven—and usually way before,—we ask our Higher Power for the power to carry out His/Her will, and for that power only. We still want no other power because we still would not know what to do with it. This means that we ask God for the power and courage to take our inventory in Step Four, to discuss it fully with another human being in Step Five, and to become entirely ready to have our defects of character removed in Step Six.

It also means that we ask God for the will to be willing to try to work the Program, for the will to choose Him rather than our own self-guidance, and even for the will to pray when we begin to falter. As long as our power and will come from God, we are all right. When we start substituting our own, or asking Him for more than just what we need to execute His will, we immediately get into trouble.

Many of us, each morning upon arising, ask our Higher Power in our own way to impart to us the knowledge of His/

Her will for us for that day and power to carry out that will. We then meditate for several minutes while we await or search for the answer. It does not always come during our meditation, but usually not long afterwards; we then set about doing God's will. We are apt to repeat this several times a day especially when we become confused, irritable, or nervous or when we face difficult tasks or decisions. Many of us repeat it regardless of circumstances, merely because of the refreshment, nourishment, and calmness we derive from it.

What other prayers can we use in this Program? Actually any prayer that gives us comfort, with only one word of caution: that it not be a prayer for our own selfish gain alone. We can, of course, continue to use such prayers, as many of us have done in the past—there is no one to forbid us or punish us if we do. But we find that with such prayers we often punish ourselves because they do not open the "uplink" channel of communication we seek, and we therefore deprive ourselves of God's help, which we so desperately need. There are two very popular prayers in the Program. One is the Serenity Prayer; the other the Lord's Prayer. The Serenity Prayer is so beautiful that we reproduce it here in the abbreviated form adopted by all Twelve Step fellowships:

God grant me the serenity
To accept the things I cannot change,
Courage to change the things I can,
And wisdom to know the difference.
Amen.

The repeated use of this prayer has kept many troubled people on a calm, even keel, many an alcoholic from drinking, many an overeater from gorging with food. The prayer is said at the beginning of all Program meetings, and repeated many times between meetings by individuals trying to practice this Program. It advises us *not* to take all the problems, real or imagined, of the world on our shoulders, but to choose, with wisdom provided by our Higher Power,

those which it is within our power to affect with God's help, and to leave alone those about which we can do nothing. In repeating and really listening to this prayer, we realize that we can only accept all things beyond our control with serenity provided by our Higher Power, if we are ready to accept that serenity. We also ask God for courage to do what we can about the things that are our responsibility so that we will not let ourselves or others down. This prayer seems to have a calming, quieting affect on all who use it. It lifts great burdens from our shoulders, so that we may have more strength for the burdens that are left—those we *can* do something about.

The other most-used prayer in the Program is the very familiar Lord's Prayer. It is voiced by all members in unison at the close of many Program meetings. Since this prayer originated with Jesus Christ according to the New Testament (Matt. 6:9 and Luke 11:2), it is the only part of the Program which seems to have a sectarian connotation. It is definitely a Christian prayer, although, through usage in the United States at least, it has become almost universal. No one has provided a good explanation for this use of a Christian prayer in a nonreligious Program, except, of course, that those who do not wish to participate in it need not do so. There is a certain amount of group pressure felt by a nonparticipant, even if not intended by the group, especially at those meetings where all members join hands while saying the prayer. For those of Jewish or Muslim faith or others who may have reservations about saying this prayer, we offer an alternative in Appendix One which we call the Universal Prayer. Perhaps with a view toward keeping the Program completely free of religious sectarianism, it might be substituted for the Lord's Prayer, which can be initially a negative factor to some newcomers. Since this Universal Prayer is completely nonreligious and nonsectarian, but rather spiritual, it moves the Program closer to its traditions, which claim and suggest complete freedom and independence from any sect or religion. It is offered only as a

suggestion; group and fellowship conscience will govern as always.

Another very beautiful prayer which is used in the Program to open many meetings, particularly on the West Coast, is the Opening Prayer. It is reproduced in Appendix Two. This prayer refers to our Higher Power as Father, Friend, and Partner. We affirm our knowledge of His presence among us, pledge to be as honest as we can be, and acknowledge our complete dependence on Him, while still recognizing and accepting our full responsibility for our end of the partnership. We then assert our certainty that we will be rewarded with "freedom, growth and happiness," and we ask for guidance and help in coming ever closer to our Father, Friend, and Partner. This is a highly nourishing prayer also, as most prayers are, and it especially enhances our feeling of closeness to God.

We do not mean to imply that the few prayers just mentioned are the only ones used in the Program, nor that there are any "official" Program prayers. Quite the contrary, the above are only suggested examples, and each member prays in his or her own way and time. We often pray with such simple words as: "God, please help me" repeated over and over again until a veil starts to lift and we feel helped, or "Thank you, God" or perhaps just "Thank you" for something nice that has happened to us—and eventually for everything that happens to us. Any prayer is appropriate if it helps the individual, and the only requirements for a prayer to be of help seem to be that it be sincere, humble, and not for our own selfish gain alone.

We have said earlier that prayer is the "up-link" and that meditation opens the "down-link." Meditation is an ancient art which has been practiced for thousands of years and is a part of all major religions, especially the Eastern. But again, it is not so much a religious practice as a spiritual one. In the West, it is a particularly strange one because it entails quieting the mind, blocking the mind and not thinking. Having become so enamored of our powers of thinking

101

and reason, it is extremely difficult for most of us to do this at first, but it is also surprising how easily it can be learned with a little willingness and a little practice.

But first, why do we wish to quiet our minds? By now, we can see many reasons. First, our conscious mind puts up all those barriers we spoke of before, and we wish to reach beyond them.

By quieting our conscious mind, we do reach beyond these barriers to our unconscious or superconscious, which for many of us is where our Higher Power resides. If, for others, the Higher Power does not reside there, at least the unconscious or superconscious is the channel through which we receive His/Her guidance. We need to quiet the conscious mind to open the channel. Third, by quieting our conscious mind through meditation, we can often quiet our emotions, which may be in turmoil. When we are troubled, the longer we continue to think about our problems, the more serious they seem to become, particularly if the problem is something we can do nothing about. Through meditation, we learn to replace such troublesome thoughts with a more constructive attitude.

Meditation helps to calm us emotionally and to relax us physically. Thus it can help us release a great deal of energy we normally expend in keeping our emotions in high gear and our bodies taut. This release of energy, which becomes available to us for constructive pursuits, accounts for the refreshing, renewing lift we experience after even a brief meditation. All those we know who have tried it for more than just a few times report being uplifted, relaxed, and refreshed by just a few minutes of meditation, whether upon arising in the morning, before retiring at night, or anytime during the day when the need arises or when the tension rises.

Finally, quieting our minds—and our bodies—helps to slow us down from the dizzying pace of activity most of us have felt compelled to maintain just to keep our heads above water in this evermore rushing, instant-everything

world. By experiencing periodic mental and physical slow-downs, we learn the value of rest and of silence. Many of us are so wound up, we find it impossible to relax or to be still. We invariably and constantly tap our fingers, jiggle a leg or foot, or shift positions uneasily. Such nervous activity at an exhausting pace is a symptom of internal stress, which is becoming increasingly accepted as a new "cause" of nervous disorder and diseases. Periodic quieting of the mind and relaxation of the body, which comprise meditation, help us to reduce such stress and to see ourselves more realistically.

Assuming we are convinced of the value of meditation, how do we go about it? How do we start? What do we do? Here again, we may borrow a page from the East. In fact, a number of Hindu techniques are becoming increasingly popular in the West. Yoga workshops and courses are being offered with increasing frequency in growth centers, adult education and activity centers, and even on television. Some are physical exercises only; others include various types of meditation. Transcendental Meditation has also enjoyed a recent Westernization. Its basis is the use of a "mantra" or personalized word or words repeated over and over as a chant to allow the mind to become free.

A Western form of meditative experience is the retreat. A group of people spend a day or weekend together in a quiet, secluded place, usually in the country or in the woods, and engage in calm spiritual discussions interspersed with periods of solitude and contemplation, either while sitting in a garden or walking through a forest or gazing into a mountain stream. Those of us fortunate enough to live in the country or in a suburb, or near an ocean, possibly have a greater choice of places to meditate. But it is quite possible to meditate at home or in church, or even in a crowded room. In the beginning we find that we do best in a quiet place, as undisturbed and undistracted as possible by external influences. What we wish to stress in Step Eleven is not a particular method or procedure, but that each person must develop and evolve the practice of meditation in the

way most comfortable to her or him. Step Eleven does not tell us how to meditate; it merely suggests that we do, if we wish to improve our conscious contact with God.

If we wish to choose one of the eighty-four thousand yoga positions, we may certainly do so, depending on the type of meditation we desire to engage in. If we are less sophisticated or just beginning, we may simply wish to sit in a comfortable chair where we may relax our body as much as possible without falling asleep, legs and feet relaxed and uncrossed; hands comfortably in the lap (usually palms upward—a receiving position), either side by side or one resting lightly on the other.

One school of thought is that a straight, vertical spine is helpful to meditation. If you wish to try this, you might sit on a reasonably firm-seated, but comfortable chair with feet flat on the floor, legs uncrossed, thighs horizontal, and your back vertical at right angles to your thighs, comfortably straight. It may be of help to imagine a reasonably taut string starting at the base of your back, going straight up your spine and out through the top of your head, the other end of the string being attached to the ceiling and holding your back and head in a comfortable straight position. Hands in the lap as before or one on each knee, palms upward.

The lotus position of yoga is exactly the same as this except that you sit on the floor, cross-legged, if possible, with each foot in the crook of the opposite knee. The cross-legged position is difficult for many Westerners and may require some practice or exercise to avoid cramps at the beginning. The important thing is to adopt the position or positions most comfortable for us—the one in which we can best relax our body. In the straight-spine position, we are less likely to fall asleep even when relaxed, and the verticality of the spine seems to help some of us experience an easier flow of spiritual energy.

At first, no position may seem comfortable and we may need to experiment a bit with several variations of our own.

As we try to relax our bodies, we may experience feelings of foolishness, of wasting time; a rush of a thousand things we should be doing may invade our minds. We recognize these as more of the conscious barriers we have already experienced when praying, and we gently resolve to continue in spite of them. We gently but firmly put aside such thoughts and continue to concentrate on relaxing our bodies. We may have to do this one limb at a time, or one foot, hand, finger or even two at a time, by consciously relaxing our muscles. Having relaxed limbs and extremities, we may then start at our pelvis and work up to our abdomen, up our back and spine (keeping it straight but not stiff), then slowly to our chest, neck, head, and face. Relaxing our facial muscles is particularly important since many of us contort our faces unknowingly when we are tense. We knit our brows, grit or grind our teeth, tighten our jaws and tongues, all without being aware we are doing it. So we consciously relax all these muscles, and as we do, try to be conscious of the energy being released and flowing out of them. We become conscious of the floor or chair holding up our buttocks so that we need not fight against it. If we are resting against a chair back or lying down, we let the chair, bed, or floor hold and support our spine so that we can relax completely. If in the vertical-spine position, we let our imaginary strings do the job.

Those of us who are more tense may have to relax in several stages or several times. Once relaxed, we may tense up again, or tighten other sets of muscles. That is to be expected, and should not disturb us. We merely check all muscles periodically and loosen those that have tightened. This is an exercise in letting go; in letting down our muscular defenses so that we may let God in (or out). In this way, we open ourselves so that our Higher Power may be able to enter our consciousness—our awareness. This may not happen for many meditation periods. But it will not happen at all if we do not repeatedly prepare ourselves by relaxing our bodies and quieting our minds.

There are several ways of quieting the mind. One is the nonjudgmental, factual review of daily activities we have already mentioned in Step Ten. By being objective, and concentrating on what we did rather than how good or bad it was, we break the normal train of activity of our minds, which for most of us is a constant stream of evaluating, censuring, judging, condemning, punishing either ourselves or others. This first level of meditation helps us interrupt this negative cycle of thought.

A next level for many of us is to try to concentrate on a single idea or image. Some members who meditate first thing in the morning use the idea of the fresh, single day ahead of them, keeping all their attention focused on this new, unmarred day. When they find their thoughts wandering away to the trials of yesterday or planning for tomorrow, they gently tell themselves to put such thoughts aside for the moment and to get back to the meditation about this day. Some think of this new day as a blank page in the book of their lives, which they will try to fill with as much love, kindness, competence, and responsibility as possible. Others think of it as a gift from God during which they will try to know His will for them and do their best to carry it out. Those for whom a whole day is too long a period to contemplate concentrate on the next five minutes or even the current moment.

This becomes easier if we start with a spiritual idea such as a Program slogan—for instance, "Let Go and Let God," which we slowly repeat to ourselves—or even a single word repeated over and over in our minds very slowly, rhythmically, and quietly, such as "Quiet, quiet, quiet..." or just a long, slow "Shhh...shhh...shhh...," possibly in time with our breathing. Some of these suggestions may seem silly to those who have never tried them, but if we can overcome that conscious barrier with enough willingness and open-mindedness to experiment a few times, the practical benefits will become self-evident and the negative judgment of silliness will disappear.

Those who prefer images to words might try to hold their concentration on a particularly pleasing, but emotionally neutral (not exciting or depressing), picture. It might be a rose or other flower we like, either in bloom or in the bud stage, a basket of fruit, a sunrise or sunset, or a candle flame. The choice is yours and should be one that has a calming effect on you.

When we first start to meditate, a minute per day, or morning and evening, may be sufficient, but even that minute may seem interminable. If we persevere without becoming upset, the minute will begin to shrink, and within days, we will find our meditations involuntarily stretching to two or three minutes or more. After a few weeks, fifteen minutes will seem like five or three, and eventually time will seem to stop entirely and stand still. We are deep into ourselves, and no longer aware of the passage of time. Not only do we no longer feel foolish, but we now look forward to our meditation periods. They give us new life, new energy, and yet serenity as we have never known it before. If we wish to go further (higher or deeper), we may then try to empty our minds of all thought. One way to begin to do this is to concentrate on a blank screen or on blackness or on total bright white light, or better yet on our own nothingness. I can offer no suggestions beyond this point because that is the limit of my own meditation at this time, but I sense that down this road lies even greater awareness of God, greater integration of myself as well as integration with Him, and greater peace, serenity, and joy.

We find that after meditating along these lines for some time—for many of us very soon—we begin to get answers to our problems and to our prayers. As we said before, the answers do not always come during our meditations; they often come immediately after or sometime during the day. One member said, "Many of mine come while looking in the mirror when shaving."

These answers to our prayers and problems usually come when we least expect them and often in completely unex-

pected ways. This is because our expectations are our own will, and not God's. When we expect a certain outcome from an event, situation, or action, we are taking our will back from our Higher Power rather than letting His/Her will be known to us. We seek God's will when we have no expectations of our own, but are willing to accept whatever the outcome is. The only expectation we allow ourselves to cultivate is a very general one that whatever our Higher Power sends our way will be the best for us—and a thousand times better than any outcome we could bring about through our will and efforts alone.

So we need to learn to recognize God's answers. To some of us they come in the form of a "still, small voice" so low we often do not hear it until its words are repeated many times. It often tells us to do something we do not want to do; so we try to censor it, and to rationalize why what the voice is telling us to do is nonsense. We may even do this before we are fully aware of what the voice said. But when we do become aware of it—and through meditation we train ourselves to be more sensitive to it—it becomes more and more difficult to ignore, particularly when we try to work and live this Program. We begin to recognize it as the voice of our own intuition, the voice of our inspiration, the voice of our Higher Self or Higher Power—indeed the voice of God.

Often the answers to our prayers and problems come through unexpected events in our lives or those of our loved ones. This has certainly been true of my life. I was unconsciously searching for wisdom and serenity long before I was consciously aware of doing it; and that in itself is a form of prayer—an unconscious wish or longing or search. For a long time, I felt I was not becoming wiser and I knew I wasn't getting more serene. Quite the contrary.

I had a management job with a great deal of responsibility (which I had wished for earlier in life) which was taking a great deal of time away from my wife and growing children. I was growing more impatient with the situation, but

felt I had to continue. To step down would be admitting defeat and humiliation. Then, one day, without any warning, after six months of telling me what a fine job I was doing, my new superior, a corporate vice-president, told me that he was replacing me. The only reason he gave was that he would like a more dynamic man in that job. Otherwise he could criticize nothing in my performance or that of the department I was managing. It was healthy, profitable, and growing. I was completely bowled over, hurt, disillusioned, and angry. He gave me a very generous nine months to look for another position, but I was not the least bit grateful at the time. I thought I had to find a job at a management level at least equivalent to or higher than the one I was leaving, though inwardly, I knew I did not want it. But I could not face anything else; it would have been a demotion. I proceeded to search the job market and executive search firms for nine months, with more than a dozen interviews but not a single offer.

The fact that this search was occurring during the spring and summer of 1969 when the 1970-71 recession was already looming on the horizon did not help matters any. But I believe the main reason I did not get any offers is that I unconsciously and half-consciously knew I did not want that type of work because of the heavy demand in both time and responsibility, which for me were no longer compensated by the satisfaction of status, prestige, or power needs. Throughout this nine-month period, I was trying to live the Program as best I knew. I was doing my footwork, and trying to leave the outcome to my Higher Power. As my termination date drew near, this was getting more difficult, but I stuck to it as best I could because I believed it was right, and I would end up doing what my Higher Power wanted me to do—not necessarily what I wanted to do, especially since I was no longer sure what that was.

About a month before my termination date, a friend who headed a small consulting firm called and asked me if I might be interested in joining his group as a consultant. He

had an assignment which fit my qualifications exactly. I joined his firm and, with that, started the most rewarding years of my life, which culminated in the writing of this book. With the help of my Higher Power, one step at a time, I am moving toward an entirely different occupation, which is so much more enjoyable and satisfying than my previous one that it defies description. I am now convinced that God knew all along what I was supposed to do and I knew it unconsciously as well. He revealed it to my conscious mind and gave me the power to carry it out as I was ready to accept it—that is, to accept Him and to accept me.

Looking back, I can see through many concrete examples that this has been the case all my life. The difference between then and now is that now I am consciously aware that my Higher Power is guiding my life, and I'm trying to cooperate with Him/Her because I like it that way. Before finding the Program, I denied the influence and accessibility of a Higher Power in my life, and kept fighting God's "will" with my own puny self-will—a very one-sided, wasteful, and losing battle, since I was fighting an infinitely powerful adversary who had not the slightest intention of fighting me, but wanted only to make His loving help available to me.

Step One
We admitted we were powerless over our emotions — that our lives had become unmanageable.

Step Two
Came to believe that a Power greater than ourselves could restore us to sanity.

Step Three
Made a decision to turn our will and our lives over to the care of God, as we understood Him.

Step Four
Made a searching and fearless moral inventory of ourselves.

Step Five
Admitted to God, to ourselves and to another human being the exact nature of our wrongs.

Step Six
Were entirely ready to have God remove all these defects of character.

Step Seven
Humbly asked Him to remove our shortcomings.

Step Eight
Made a list of all persons we had harmed, and became willing to make amends to them all.

Step Nine
Made direct amends to such people wherever possible, except when to do so would injure them or others.

Step Ten
Continued to take personal inventory and when we were wrong, promptly admitted it.

Step Eleven
Sought through prayer and meditation to improve our conscious contact with God, as we understood Him, praying only for knowledge of His will for us and the power to carry that out.

Step Twelve
Having had a spiritual awakening as the result of these steps, we tried to carry this message to others, and to practice these principles in all our affairs.

Step Twelve

So we come to Step Twelve, the last step of the Program. AA tells us: "The joy of living is the theme of [the] Twelfth Step, and action is its key word" *(Twelve Steps and Twelve Traditions,* Alcoholics Anonymous, p. 109). Is this truly possible? Ater all the sorrow and pain we have known, can we really experience the joy of living? The answer, based on our experience, is a definite *yes.* And this step tells us how.

First, it says that if we practice the other eleven Steps to the best of our ability, we will have a spiritual awakening. Second, it suggests that we try to carry the message of this Program to other people who are still searching for a way of life which will fill their spiritual vacuum and restore them to sanity. And third, it recommends that we try to practice these principles in *all* our affairs. Let us look at these three parts one at a time.

A spiritual awakening may be not only a new experience for most of us, but a new phrase. At first we are not sure what it means, and one reason for this is that it means different things to different people and at different times. It may be quite sudden, or very gradual. It may be an emotionally packed experience that bowls us over. Or it may be

barely perceptible when it occurs, with its full significance entering our awareness only after it has happened; we realize in retrospect that we have had a spiritual awakening. Many of us may begin to have a series of small spiritual awakenings, which have also been called "deepened spiritual awareness" from the moment we go to our first meeting. We may sense immediately when looking into people's faces, seeing them smile, hearing their laughter, watching them hug and kiss each other, that the people in this Program have something we want. We may not know what the "something" is, but we feel a sense of hope down deep inside. Our spiritual core has been touched and, as a result, we are no longer the same lonely, despairing person. Though it may still be shrouded by heavy dark clouds, a ray of sunshine has entered our lives, perhaps the first in many weeks or months of struggling with problems we could not solve. From this small beginning, which for many of us may not occur until much later in the Program or may occur in an entirely different way, we all progress to further awakenings as we begin to learn, practice and live the Twelve Steps. The book *Twelve Steps and Twelve Traditions* of AA describes it as follows:

> When a man or a woman has a spiritual awakening, the most important meaning of it is that he has now become able to do, feel, and believe that which he could not do before on his unaided strength and resources alone. He has been granted a gift which amounts to a new state of consciousness and being. He has been set on a path which tells him he is really going somewhere, that life is not a dead end, not something to be endured or mastered. In a very real sense he has been transformed, because he has laid hold of a source of strength which, in one way or another, he had hitherto denied himself. He finds himself in possession of a degree of honesty, tolerance, unselfishness, peace of mind, and love of which he had thought himself quite incapable. What he has received is a *free* gift, and yet usually, at least in some small part, he has made himself ready to receive it (p. 110).

So a spiritual awakening is a "gift which amounts to a new state of consciousness and being." It is usually accompanied by a complete change of values. Our old values were

114

based on the pursuit of things and objects, of the "good life," which meant the materially comfortable life. Most of us even treated our families, friends, acquaintances, and other people as things and objects to be used, exploited, or manipulated for our own gain and benefit. We thought that we must fend for ourselves; "make it" on our own; "make it to the top of the heap," and make sure we stayed there at all costs. When we found that there was only a limited amount of room at the top and most of it was already staked out or claimed by others, we either scrambled and fought that much harder or became disillusioned, discouraged, and often apathetic.

Our new values are based on a realistic view of ourselves as children of God made up of physical, intellectual, emotional, and spiritual elements. We recognize that we need a balanced *integration* of these if we want to lead a happy and serene life. We know that, since our emotional and spiritual components are highly underdeveloped, we need to concentrate considerable energy on their development. We recognize that spiritual development is our Number One priority, at least until we have achieved the balance we seek within ourselves. We know that, if we develop and grow spiritually, our emotional development will follow, either with the help of this Program alone or the additional aid of therapy, counseling, or encounter groups.

Having taken good care of our spiritual component, we realize that many of our old fears have left us; many of our compulsions have disappeared; and all of our addictions and obsessions have been lifted from us. We are no longer depressed, because we have discovered the joy of living. With the help of our Higher Power, we have discovered new faculties in ourselves we never knew existed. We found that our Higher Power has given us the strength and energy to do things we had thought about for years, but kept putting off because of fear of failure. Our indecision has been reduced, and our decisions are more often good for us than bad. If we have felt trapped in a job we hated but thought we could not

leave because of our need for financial security, we now find the courage through trust in God to make a change which will bring us greater satisfaction, fulfillment, and serenity. Or, our new attitude of service and contribution to others renews our interest in our work and the benefit we derive from it.

People are no longer objects to be exploited in our attempt to fill our own spiritual vacuum because we have now filled it with this Program and a new growing relationship with our Higher Power. We find that people are here for us to love, care for, interact with on a friendly basis, give warmth to, and appreciate as growing and developing human beings like ourselves. As our spiritual awakening continues, we become more lovable, make new friends more easily, and feel comfortable with other people. Our relationships with our families improve endlessly, as we are drawn closer to each other yet recognize the independent dignity of each human being. Our need to dominate, control, or be controlled is greatly reduced. We simply try to live joyfully as interdependent human beings, knowing that our only permanent dependence is on our Higher Power, and that this Power is the only source of our strength and of our supply.

We no longer have unrealistic expectations about ourselves or others. We are learning to accept ourselves as we are, with all our faults, and therefore can accept others as they are. We cannot be seriously disappointed for long periods of time. We know that our Higher Power intends the best for us and that, if we continue to improve our contact with Him/Her, nothing can go wrong.

This does not mean that we are living in Utopia—far from it. We still encounter our share of problems, troubles, even calamities and catastrophes. But we have learned that these are *always* opportunities for further growth and development. When these things happen, we try not to feel sorry for ourselves, or that God has abandoned us. We do not think how unfair it is that He is punishing us when we

have been working and living our Program to the best of our ability.

Quite the contrary, we learn to accept what comes our way with increased serenity and ask what, if anything, we have done that might have brought about the unhappy situation. We do not blame others; we do not blame God; we do not blame or punish ourselves. We merely look for what lesson we are supposed to learn from the unhappiness and try to learn it. Perhaps it is that we need to pray and meditate more. Though we have done it daily, perhaps we have been distracted or not listened well to the messages from God.

Perhaps, if we have lost a job, we were engaged in an activity not suited to our capabilities, and we are supposed to change course. Or if we have lost a loved one, perhaps we were becoming too dependent on that person and it is time for us to learn to rely more on ourselves and our Higher Power. If we contract a severe illness or have an accident, we might have been engaged in too many activities to devote enough time to spiritual growth. We probably need a long period of rest to prepare ourselves spiritually for our lives ahead. Whatever the disaster, the suffering or the inconvenience is usually a blessing, even though sometimes in a very horrible and painful disguise.

If we will but look under the disguise, however, and allow sufficient time to pass for us to adjust emotionally and spiritually to the new situation, and if we will continue to look to our Higher Power for help—perhaps more than ever—we will eventually find that a new direction or dimension of growth will emerge from a bad or even terrible situation. The rewards will be greater than the pain we suffered. In that sense, we truly suffer to grow.

Through our spiritual awakening, we also realize that we—each of us—must go through our own pains and suffering to an extent determined primarily by our inherited characteristics and our early conditioning. The amount of suffering we must bear prior to our spiritual awakening—and while going through it—is a completely individual

matter. No one can change this for anyone else. We can possibly make it easier for others by being available when they need us; by standing by in moments of need; by being a friend to talk to or just to listen; or even by offering an occasional shoulder to cry on; but we cannot basically change the degree of suffering any individual must go through. This is determined entirely by each person and by his or her previous environment. Each of us must go through whatever pain we must. The point is that we must go through it rather than avoid it, because the pain of avoiding is far worse in the long run than the short-lived pain of growth.

These thoughts bring us to the second part of Step Twelve: "We tried to carry this message to others." There are many reasons why we try to "carry this message." One of them is that this is how the Program grows, prospers, and flourishes—by members who have been practicing it a while helping newcomers. There are no leaders, no authorities, no "senior members" in this Program. In a very real sense, we are all newcomers when we uncover a new facet of ourselves we had not known before, and this happens often since we are all infinite in our unconscious. But by sharing our experience, and how using the Program has helped us over our many rough spots, we may help the newcomer find new hope and courage.

Another reason we try to carry the message is that newcomers to the Program, and others who have never heard of this Program, are often troubled, confused, and resentful. When they have decided to do something about themselves, and are confronted with the Twelve Steps, they often want to "gobble" the whole Program at once so that they will feel better fast—"instant relief," as the perennial commercial promises. But there are no promises of instant relief in this Program. There are promises only of relief, as well as love, serenity, joy, and new energy, if we painstakingly work our way through each Step, one at a time, taking as long with each one as we need to before proceeding with the next, and going back to previous Steps whenever the need

arises. This is part of the message we need to carry to the newcomer, that much more than instant relief will come in time—when he or she is ready for it.

Many newcomers need guidance—not advice—in being gentle with themselves; in doing what is comfortable for them; in learning to be good to themselves; in beginning to know what it feels like to like themselves; and, perhaps most of all, in patient and diligent work on the Twelve Steps.

The most important reason we try to carry this message is that we must do it to help ourselves grow. This is another of the paradoxes of the Program: that we must give it away to keep it. To continue our emotional and spiritual growth, we must learn to give to others freely and without expectation of external rewards. Only by learning the internal reward of giving without expectation of return can the alcoholic stay sober, the addict stay away from drugs or food, the neurotic keep out of depressions or other crises. We must give of ourselves, not just once in a while, but on a daily basis. One of the best things we can give another person, if it is wanted, is what we have been so freely given in this Program.

Working with a newcomer is one of the most rewarding things we can do. It is scary at first, for we tend to think we are not ready to give anything away since we have not yet gotten enough Program ourselves to give away, and the Program says: "You can't give away what you don't have." But when the opportunity comes, when God sends us a newcomer to work with and to help, then we must take His word for it that we are ready, whether we feel it or not. We ask for His help in guiding the newcomer in a way that will help him or her. This does not mean that we spout God and Higher Power in an endless stream of enthusiasm about the Program. We do not even reel off all the things we like best about the Program. Rather, we first attempt to find out all we can about our newcomer to place ourselves in a better position to be of help.

Some of us are sometimes so enthusiastic and grateful

about this Program, because we have been helped so greatly and so far beyond our expectations, that we must remind ourselves often while working with newcomers that we must depend on "attraction rather than promotion." The results will be better if our talk is quiet and compassionate. If we sound evangelistic or crusading—or if we pressure, coerce, insist, argue, or even press a point too hard—we may well scare away someone who still feels powerful enough to solve all problems, and who fears making a commitment of any kind and resents being told what to do. We must convey the message that the decision to join this Program in earnest is an entirely individual one. This is made by most of us when we reach the point where we have suffered enough and are tired of hurting, of finding only problems and no solutions, of living in emptiness and meaninglessness—in other words when we have hit our own individual "bottom," whatever that may be for us. We do not—in fact most of us cannot—"buy" the entire Program all at once. We must *let it come to us* slowly and gradually by exposing ourselves to its principles, its Steps, and its participants at frequent meetings.

An important thing to remember when sharing with newcomers is best expressed by Vincent Collins in a small booklet entitled *Acceptance:* "I finally learned that you cannot help people unless they really need help, are willing to be helped, want you to help them and ask you to help them. Even then, you can only help them to help themselves." We can best do this by helping them get to meetings and by using the telephone between meetings either for a friendly chat or to help someone (ourselves included) over a rough spot.

For most of us, the third part of the Twelfth Step is probably the most difficult: "...we tried...to practice these principles in all our affairs." This is the crucial part of the Step for all of us who have found that the principles expressed by these Twelve Steps were of immeasurable help to us, not only in recognizing, admitting, and being delivered from

our neuroses, but in living a sane and serene life based on continued spiritual development. We have found that these Steps apply not only to emotions, excessive use of alcohol, food, or other addictions; *they apply to life.* They are a way of life for all of us, which can lead us to peace, serenity, and to God if we want Him and allow Him to enter our consciousness.

When we experience our spiritual awakening, we begin to realize that all the problems of the world, which we thought were ours to solve, can begin to be solved if we will but start with the part we can do something about—ourselves—and continue to work on ourselves with the help of our Higher Power and these Steps, one day at a time.

We now understand that we cannot achieve peace in the world at large until we achieve peace within ourselves; that we cannot achieve peace and serenity within ourselves independent of a Higher Power and the spiritual development that comes from integrating our Higher Power into our conscious lives. Furthermore, to embark on the road toward spiritual development, we know that we must first become aware of our spiritual vacuum which has resulted in our current insanity. We must individually admit we are powerless, and stop attempting to overcome our collective powerlessness with ever larger and more devastating weapons of destruction or other material goods, or by continually trying to exert power over those around us. We need to begin to work on our own individual spiritual development, and continue to work on it on a daily basis, one day at a time, for the rest of our lives. The easiest way we have found to do this is with the help of a simple program such as the one outlined here.

It may still seem impossible to those who have not yet tried it to "practice these principles in all our affairs," but let us look at two examples which affect most of us: our families and our work.

For many of us, our relationships with our spouses are often carried on military style or on a commercial basis. We

turn our homes into battlefields or into marketplaces. We are either launching verbal salvos, fighting skirmishes, protecting our flanks, or we are trying to buy our spouse's love or approval with money, pseudo-kindness, or over-consideration at our own expense. Psychologists and psychiatrists tell us that many of us adopt relationships with our spouses which are continuations of unresolved conflicts with our parents. In these battles or commercial transactions, we use every weapon or object available to us including intellectual capacity, "feminine charms," sexuality, money favors, and even our children. It is a terribly destructive, manipulative game—a battle of wills which often ends in separation, divorce, or on rarer and more severe occasions, even murder or suicide. The main problem in these situations is that each party blames the other: "If he weren't such a mean bastard, I could be a nicer person." Or "How can any man live with a shrew like her and remain sane? If only she'd shape up, we could have a good marriage." Further, both parties feel they are responsible for changing their partner to suit themselves, but neither admits that there is anything to be changed within themselves. They both devote their total effort and energy to the impossible task of changing the other person.

With the Program, all this changes. Not overnight, perhaps, but over a period of time. When both the husband and wife try to live by this Program, the marriage cannot help but succeed. Even with only one spouse trying to live the Program, the situation is greatly improved. We find other options besides divorce, murder, or suicide. We learn by modifying Step One a bit that we are completely and absolutely powerless over our spouses and we admit that trying to change our spouse has made our lives unmanageable.

This admission of powerlessness over other people is called "release" in the Program. It is absolutely essential that we learn to release others so that we can begin work on ourselves. If we continually criticize, judge, evaluate, or complain about the behavior of our spouse or anyone else;

or even if we continually complain about life in general, and how cruel it has been to us, we cannot possibly see the true cause of our problem—US. We continue to hide the real problem from ourselves, and thus can solve nothing. When we finally release, we are then free to begin work on the real problem—ourselves, where our efforts can begin to do some good, with the help of the Program.

As we continue, we soon recognize that without the help of a Higher Power we are just as powerless to change ourselves, and many of us must release ourselves as well. We come to believe that a Power greater than ourselves can and will restore us to sanity if we cooperate. We slowly become aware of the areas of insane behavior in our lives, toward ourselves, our spouse and others. We admit that we will need God's help to restore us to sanity, since we have not been able to do it on our own.

In Step Three, we complete our release by turning our spouse, as we did ourselves, over to the care of God, as we understand Him. We come to believe that it is not our job to control or change or run our spouse's life, but God's. We cannot even wish for our spouses to be different in any way, because such wishes prevent us from trying to accept our spouse *exactly as he or she is;* which is the only thing we can do if we wish to grow spiritually. We recognize that God can do a much better job of helping our spouse to change than we have, and make a decision to give Him a chance. Further, we realize that we will have our hands full just trying to find what His will is for us and asking for the power to carry it out. Next, we search our hearts fearlessly and, with the help of our Higher Power, include in our inventory all areas where we know we have not released. Perhaps we have yelled, screamed, or threatened or cried or complained or made big scenes to "get our own way." Or perhaps we have nagged or cut down our spouse in sneaky, hostile ways: "Have you noticed how you always need to be center of attention at parties, dear?"

We think we need to point out such things to our spouses;

otherwise they would never know. After all, we justify, we are only trying to help. But we really are not. We are really saying: "I resent you always being the center of attention, because I can never get a word in, and I feel neglected and envious. I want to be the center." We need to zero in on our own feelings of neglect, loneliness, resentment, and envy. We write them all down. That is what a "searching and fearless moral inventory of ourselves" is. When we are finished writing about the obvious things, we go back once more and look for the more subtle ones. If we are not sure whether we are wrong or not, or if we feel only partly wrong, we write it down anyway—the pros and the cons, the worst we suspect about ourselves as well as the justifications and rationalizations. Once on paper, it is surprising how the rationalizations will jump out at us and how much easier it will be to see the truth than when we had it all jumbled together in our heads.

We need to take an equally honest look at our sex life. Again there will be obvious areas where we have deviated, had affairs, perhaps even flaunted them at our spouse, using them as a weapon in the ongoing warfare. But we need to search out the less obvious areas where we have been at fault. Perhaps we have been too demanding or too passive in our sexual relations with our spouse. Or we have not been considerate of our mate's needs; we have not been available when we were needed, or have not kept ourselves as attractive as we might have. We may have become obese or slovenly and just let our appearance deteriorate. We may wander around the house all weekend unshaven with a stubble on our face and wearing our old dirty pair of pants and a ragged holey sweater. Perhaps we haven't even taken showers or bathed often enough or used deodorant when appropriate. Possibly we have been inhibited in our sex life, so afraid of trying new variations, new "sauces and pickles" as they are called in *The Joy of Sex,* that we have turned off both our partners and ourselves with boredom and monotony. We write all these down and acknowledge our part of

124

the wrong—our contribution to the bad situation. We accept it and ourselves as we are—without hiding, without excusing, without justifying or rationalizing—just the plain honest truth. Having done this, we are ready to admit all these things to God—though He knows them already—and to another human being.

Some of us may be tempted in our newfound honesty to rush to our spouse and confess everything. Indeed this seems like a worthwhile course of action; we could even combine Steps Five and Nine, making amends at the same time. In a few cases, such a shortcut may be possible, but if we decide to try it, we must use extreme caution. Many of us who have tried it or seen it tried would not recommend it. To be ready for such a move, we should have removed any trace of hostility or anger we might have had toward our spouse. If there is any hidden hostility left within us, we will surely start an argument rather than make amends, and we are highly likely to say or "confess" something that will hurt our spouse. Hidden or repressed hostility has a way of making us do that.

The best way we know to assure that we have removed all traces of hostility and resentment is to take Steps Five, Six, and Seven in order, and to give each one due time before proceeding with Eight and Nine. This means, in most cases, we should discuss our inventory, not with our spouse, but with a third party as discussed under Step Five.

Then we must become "entirely ready to have God remove our defects of character," including the causes of our sexual misbehavior which may well be related to the hostility, resentment, and anger expressed in both the overt and covert war we have been waging with our spouse. If we have been truly honest with ourselves, with God, and with our third party friend; have become sufficiently humble to admit fully our part of the trouble without any expectation that our spouse will admit to partial responsibility; sincerely wish to improve our relationship with our spouse; and are willing to do anything we can to bring about such

improvement, then we are ready to "humbly ask God to remove our shortcomings," and He will. He may have done a large part of that removal already, as we were going through Steps Four through Six, without even being formally asked, if we were asking Him unconsciously all the while. This means that we have fully accepted our behavior, good and bad, right or wrong, and have completely forgiven ourselves without any unconscious reservations. If we have the slightest unconscious reservation, we can ask consciously all we want. It will not help. If we have absolutely no unconscious reservations, we often do not have to ask consciously at all, but we usually do so anyway, to assure ourselves that we have removed all our conscious barriers.

Then, and only then, are we ready for the amends of Step Nine with our spouse. If we make amends then, in a state of complete grace and humility, with love, compassion, and forgiveness in our hearts, free of any vestigial hostilities and resentments, we will find that we will feel closer to our spouse than we ever have before—even during our honeymoon. Perhaps for the first time in our lives, we will begin to get an inkling of what true marital love really is. We will begin to see how the principles of the Program can be applied to the family area. To practice release with all our family, we need now to go through the steps similarly with our children, our parents, and any other close relatives we may have a need to.

All well and good; the Program works in the family area if we use it and learn to live it. But what about work? Can we really admit we are powerless in that area of our lives? After all, our jobs are the way we earn our living—our bread and butter. If we are powerless here, we may well starve to death—or at least have to go on welfare. But those of us who have tried to practice these principles in our work can report with an unqualified YES that the Program does work if we are willing to trust our Higher Power.

Those of us who work in an organizational hierarchy might start at the easiest point—releasing our bosses. We

turn them over to our Higher Power. As we practice our Program, learn more about ourselves through honest inventories, and accept what we learn, we become better able to accept our bosses as they are—even those who shout and bark out orders, threaten, and shake their fingers at us. We realize that these people, like us, have their own problems. They are fighting their own internal battles, and they must often externalize these battles toward whoever happens to be near them. Like us before we started our spiritual and emotional development, they project the feelings they have about themselves onto others to avoid looking at themselves and accepting characteristics they consider unacceptable.

When we release these people—when we realize that what they say is not necessarily directed at us—when we are able to examine objectively their accusations and own up to the parts that may be true and let the rest go—when we concentrate on identifying, accepting, and asking our Higher Power to remove our own shortcomings—when we are willing to make amends for our own negative behavior—when we really do the best we can without resentment and become willing to accept whatever outcome God decides for us instead of the one *we want* or think we deserve—then we will find our relationships with bosses and others at work greatly improve; our serenity and calm even under difficult situations remain relatively undisturbed; and we are able to do our work with greater effectiveness and efficiency.

If our past self-expectations were unrealistic, we may not do as much work as we once thought we should or could, but we do as much as we can while maintaining our serenity; and what we do is done better. On the other hand, many of us find that with the help of our Higher Power to handle all the important decisions, and with many of our internal conflicts resolved or removed, our minds are clearer, our concentration better, and we can do much more work than we could in the past.

"Okay, so these principles can be applied successfully to

our bosses at work!" But what about those of us who are managers or who run our own businesses? Isn't our responsibility to tell our subordinates what to do and how to do it, and to see that it gets done, and "gets done right"? How can we do that if we admit we are powerless over all these people and their work? After all, we are paid to manage, not to admit that our lives at work are unmanageable. Therein does appear to lie a serious conflict, but many of us have found that it is not.

We have come to realize that most of our current ideas of management have evolved from the principles of command of the Roman army. We are now learning that these basic principles of autocracy, chain of command, and unquestioned authority of one human being over another can—and often have and do—lead to tyrannies and consequent oppression and corruption. If there is a conflict, it is not between our powerlessness and the management of affairs; it is between the autocracy of management as we have practiced it and the democracy of government that we cherish so dearly. We have taken it for granted that to run or manage a business effectively we must exercise authority over others, because the commercial system within which we live seems to encourage people to work for their own selfish ends, to put themselves ahead of everyone else, and to grab whatever they can by their brawn or wits at the expense of others who might be less generously endowed.

When we experience a spiritual awakening as a result of living this Program, we have said that our values change. We no longer place material gain or status or power over others ahead of everything else. We no longer participate in the corporate game of climbing to the top of the heap by scheming, manipulating, maneuvering, or buttering up the higher-ups. We no longer need to pass ourselves off as something we're not because we become evermore accepting of ourselves as we are. Since we have less and less need to hide from ourselves, we do not need a big ego to cover up the parts we deem unacceptable. Along with our ego, our

false pride is reduced. We can now do the most humble work, when necessary, without feeling that it is beneath us or that we deserve better. We no longer need to manage by dominating others because of fear that, if we don't, they will dominate us. Though we may be managers, we can now accept ourselves as equal to everyone else, with more capabilities than some people in some areas and less in others. If someone tries to dominate us, we do not have to respond by being or acting dominated, or with fear or anger. We now know that we have the option of withdrawing with dignity and staying away from such persons as much as we can until such time as we learn to see them and ourselves more realistically.

We look at our management work as an opportunity to serve rather than as a status symbol and a means of earning more money. We need neither money nor status to make us feel important because we have begun to appreciate ourselves internally. We know that in God's eyes, and now in our own as well, every human being is important. In short, we no longer need to manage by autocratic principles but are now able to manage by true democratic principles, based on the recognition of individual dignity and the inherent worth of every individual. Instead of expecting our subordinates to adapt to the workplace, we look for ways to improve the places where people work. We realize that workers and managers alike are individual human beings, each striving to become an integrated physical-intellectual-emotional-spiritual entity. Instead of maximizing profits in the short run, we attempt to maximize the spiritual, emotional, intellectual, and material rewards to all concerned— stockholders, customers, managers, employees, and the community at large.

We recognize that the only sane way to live is to place a higher value on our spiritual development than on material acquisition. We now know that reversing these values as we did in the past leads to insanity and death. Further, we value the worth of every individual. Recognizing that there

is usually more than one person fitted for a given job, we rotate leadership periodically, thereby giving every person an opportunity to test various positions, and thus to find the one or ones in which each person performs best. Periodic rotation of managers also prevents operation of the well-known principle wherein a person is permanently promoted to his or her level of incompetence. Status becomes almost nonexistent since each manager is in a given position for only a short period of time. Thus status is replaced by service; managers do not "govern," they serve, just as one does in any other position.

Poppycock! you say; no business can operate on such a basis. It would go broke. True, if attempted today with emotionally and spiritually undeveloped people, such policies would be doomed to failure in most cases. But the changes we speak of can be implemented gradually and proceed apace with people's spiritual development. As managers in the business world develop themselves spiritually, they will begin to see how the principles of these steps apply to all their affairs. They will begin to lead the way rather than lag behind and impede the movement toward greater development and freedom. Those of us who work in business and are applying these principles can report enthusiastically that our working environment has improved considerably as a result of these Steps. When our attitudes change, the attitudes of those around us seem to change as well, and the workplace becomes a much more pleasant spot for all concerned. To our current knowledge, no business has been known to founder as a result of the application of these principles. Quite the opposite—a number of businesses have been known to mushroom and flourish.

So we have found that the Program does work in all areas of our lives. All we have to do is to be willing to try it. We find that, as our faith in our Higher Power grows, we become more willing to trust and to leave more and more of the decisions of our lives and the outcomes of those decisions to that Power. Our trust continues to grow as we see

130

the results of seeking our Higher Power's help in more areas of our lives; and as our trust grows, we, in turn, become more willing to entrust still more of our lives to Him/Her. For many of us, spiritual development is exactly this kind of gradual, regenerative, neverending process. We slowly become God-oriented, and thus, for the first time, learn the true meaning of love, of growth, of serenity, of "Peace on Earth and Goodwill toward All."

SUMMARY

By now, we hope we have conveyed the idea to you that the Program we have described is unique. It is spiritual though not religious; it is emotional though not group therapy; it is individual though practiced with and through the help of others; it is entirely voluntary, and the only requirement is to be willing to try; it costs little or nothing monetarily or as much as we can afford; it is based on love, caring, and understanding. It fills our spiritual vacuum; it restores us to sanity; it shows us how to live with joy and helps us learn how to love.

Most important, it is not a program of faith alone, but of faith combined with action. Believing in a Higher Power is necessary but not sufficient; professing what we believe is helpful but not enough. If we want what this Program has to offer—serenity, peace of mind, love, and spiritual growth—we may start by reading, believing, and professing, but we must eventually come to practicing, applying, using, and living its principles.

Most of us find that we must replace all our old ideas and concepts of life which tend to be limiting, negative, and downright destructive with positive thoughts based on the contructive principles of the Program. We must replace self-confidence with trust in our Higher Power, over-inflated egos with humility, rationalizations and self-justifications with honesty and truth. As we begin to do this, faith replaces worthlessness; action replaces indecision; prayer and meditation replace idle, depressive thoughts which used to course through our brains like endless tape loops.

We also learn to concentrate on improving ourselves and to "release" all others. The old cliches "keep your own

133

house in order" or "physician, heal thyself" come to have new significance. As we concentrate on our own spiritual progress, we stop judging, criticizing, and condemning ourselves and others. We try to remember that we are not engaged in a race with anyone or anything—not even ourselves or the clock.

We do not compare our progress to that of others because were we to do so, we would be comparing our *internal* feelings and emotions with their *external* appearance and expression—a poor comparison at best. The important thing is that we make progress one day at a time—not how fast we learn the "course material." Our progress has nothing to do with our intelligence or intellectual capacity. It is more closely related to the emotional and spiritual resistances and defenses we have built—both conscious and unconscious—as a result of our reaction to our past emotional and spiritual environments and inherited capacities.

We know that the more we learn to trust our Higher Power, the more spiritual progress we will make, but we cannot rush the process. It seems that the more we rush and push, the slower progress we make. Spiritual progress is not a matter of determined will; it is a matter of letting go, letting be, accepting what is, and letting our Higher Power make our decisions for us—seeking His/Her help on a constant, ongoing basis. We cannot learn to live this program overnight any more than we learned our previous ways overnight. For most of us, it is a long, slow process, but we know that if we continue to try, to attend meetings, to accept the responsibility for our own growth, to help others who are new to the Program, the rewards will be ever greater. We learn to live comfortably, serenely, and joyously in the here and now, one day at a time—or one minute at a time, if we have to. At each stage of development, we marvel; incredulously, we ask: "Can it really get better than this?" And sure enough, it does!

APPENDIX ONE

The Universal Prayer*

Eternal Reality, You are Everywhere.
You are Infinite Unity, Truth and Love;
You permeate our souls,
Every corner of the Universe, and beyond.

To some of us, You are Father, Friend or Partner,
To others, Higher Power, Higher Self or Inner Self.
To many of us, You are all these and more.
You are within us and we within You.

We know You forgive our trespasses
If we forgive ourselves and others.
We know You protect us from destructive temptation
If we continue to seek Your help and guidance.
We know You provide us food and shelter today
If we but place our trust in You
And try to do our best.
Give us this day knowledge of Your will for us
And the power to carry it out.
For Yours is Infinite Power and Love, Forever.
Amen.

*This prayer is offered as a spiritual but nonreligious closing prayer for fellowship meetings for those of non-Christian faiths or of no specific faith who might feel strange about using a prayer associated with the Catholic and Protestant religions.

APPENDIX TWO

Suggested Opening Prayer

Our Father, we come to You as a friend.
You have said that where two or three are gathered together in
Your name, there You will be in the midst.
We believe that You are here with us now.
We believe this is something You would have us do, and that it
has Your blessing.
We pledge with You always to be honest, and to search our
hearts for weaknesses and errors that we may deserve Your
help.
We believe that You want us to be real partners with You in
this business of living, accepting our full
responsibilities and certain that the rewards will be
freedom and growth and happiness.
For this we are grateful.
We ask You at all times to guide us.
Help us daily to come closer to You and grant us new ways of
living our gratitude.
Amen.

Prayer of Saint Francis of Assisi

Lord, make me a channel of Thy peace—
That where there is hatred, I may bring love—
That where there is wrong, I may bring the spirit of
 forgiveness—
That where there is discord, I may bring harmony—
That where there is error, I may bring truth—
That where there is doubt, I may bring faith—
That where there is despair, I may bring hope—
That where there are shadows, I may bring light—
That where there is sadness, I may bring joy.

Lord, grant that I may seek rather to comfort
 than to be comforted—
To understand than to be understood—
To love, than to be loved.

For it is by self-forgetting that one finds.
It is by forgiving that one is forgiven.
It is by dying that one awakens to Eternal Life.
Amen.

The Twelve Traditions of
Spiritual Development Groups and Fellowships*

1. Our common welfare should come first; personal progress for the greatest number depends upon unity of our group and our fellowship.**
2. For our group purpose there is but one ultimate authority—a loving God as He may express Himself in our group conscience. Our leaders are but trusted servants—they do not govern.
3. Any two or three persons who wish to grow emotionally and spiritually, when gathered together for self and mutual improvement, may call themselves a fellowship group. The only requirement for membership is a desire to feel better.
4. Each group should be autonomous except in matters affecting other groups or the fellowship as a whole.
5. Each group has but one primary purpose—to carry its message to the person who still suffers.
6. A group of this fellowship ought never endorse, finance or lend our fellowship name to any related facility or outside enterprise, lest problems of money, property and prestige divert us from our primary purpose.
7. Every fellowship group ought to be fully self-supporting, declining outside contributions.
8. Our fellowship should remain forever nonprofessional, but our service centers may employ special workers.
9. Our fellowship, as such, ought never be organized; but we may create service boards or committees directly responsible to those they serve.
10. Our fellowship has no opinions on outside issues, hence our name ought never be drawn into public controversy.
11. Our public relations policy is based on attraction rather than

promotion; we need always maintain personal anonymity at the level of press, radio, TV and films.

12. Anonymity is the spiritual foundation of all our Traditions, ever reminding us to place principles before personalities.

*These are the Twelve Traditions of the AA Program with minor modifications for wider applicability.
**Wherever the word "fellowship" appears, a specific fellowship name may be substituted.